BETTER PI

Travel

A RotoVision Book
Published and Distributed by RotoVision SA
Rue Du Bugnon 7
CH - 1299 Crans-Près-Céligny
Switzerland

Tel: +41 (22) 776 0511
Fax: +44 (22) 776 0889

RotoVision SA, Sales & Production Office
Sheridan House, 112/116A Western Road
Hove, East Sussex,
 BN3 1DD, England

Tel: +44 (0) 1273 72 72 68
Fax: +44 (0) 1273 72 72 69

Distributed to the trade in the United States:
Watson-Guptill Publications
1515 Broadway
New York, NY 10036

ISBN 2-88046-325-4

Book design by Brenda Dermody

Production and separations in Singapore by ProVision Pte. Ltd.
Tel: +65 334 7720
Fax: +65 334 7721

BETTER PICTURE GUIDE TO

Travel photography

MICHAEL BUSSELLE

Contents

The Main Themes

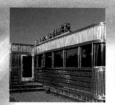

K. COOCH

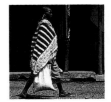

I

You are bound to have favourite subjects for photography,
but it's important to shoot a range of different themes so
you can capture a good all-round impression of the place you have visited. Taking pictures
from each of the groups listed in this chapter will ensure you will return with a selection which
encapsulates the character and
atmosphere of the place.

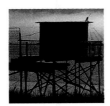

Of all the travel and landscape subjects, a beautiful view is probably the most commonly photographed. It is also, paradoxically, one of the most difficult from which to produce a striking image. The prime reason is that there is often a temptation to include too much in the frame which can result in an image which has no immediate focus of attention and too many conflicting details.

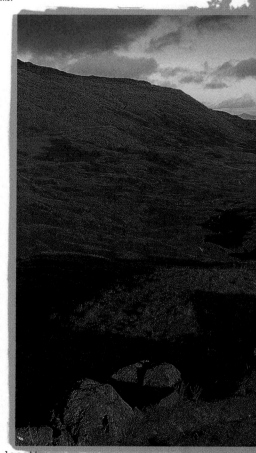

Seeing

It was the broad expanse of this Cumbrian scene which appealed to me combined with the rich autumnal colours. The clarity of the late afternoon sunlight was ideal for shooting a distant view and the strong shadows it created also enhanced the texture and contours of the landscape.

Thinking

I wanted to convey a strong impression of depth and distance within the scene which the foreground rocks accentuate. The small highlighted cottage in the valley and the V shape in the horizon created a focus of attention for the composition.

location
Hardknott Pass - Cumbria UK

Technical Details
6x4.5cm Single Lens Reflex -
55mm lens, polarising,
81C warm-up and neutral-
graduated filters,
1/2 sec at f22, Fuji Velvia.

Rule of Thumb

When both close and distant details are included in the image set a small aperture to ensure adequate depth of field and focus at a point about a third of the way between the nearest and furthest details.

location
 Near Consuegra - La Mancha, Spain
This scene was shot in the softer light of a hazy summer day. I used a long-focus lens to isolate a
small area of the scene and maximise the colour and pattern within the landscape.

Technical Details
35mm Single Lens Reflex -
200mm lens, polarising,
81C warm-up, and neutral-
graduated filters,
Fuji Velvia.

Acting
I chose a viewpoint which enabled
the rocks to almost fill the
foreground and used a
wide-angle lens to
include as much of the scene as possible. I used a
warm-up filter and polariser to emphasise the rich
autumn colours.

Rule of Thumb

When using a graduated filter to
make an area of the image darker
it's best to take the exposure
reading before fitting the filter. If
you are using the filter to correct
an overbright sky it's best to take
the exposure reading with the
filter in place.

Seeing

The contrast between the grey, wintry snow-
capped mountain and the fresh spring-like green grass
lit by a pool of sunlight was the inspiration
for this shot.

Thinking

I wanted to accentuate the contrast
between these two elements and keep the
composition as a simple division of layers, one
third mountain and two thirds grass.

Technical Details ➤
6x4.5cm Single Lens Reflex -
105mm lens neutral-graduated and 81C
warm-up filters Fuji Velvia.

location
Puy de Sancy, near le Mont Dore - Auvergne, France

Technical Details
35mm Single Lens Reflex - 150mm lens
neutral-graduated and 81C warm-up
filters Fuji Velvia.

location
Sierra Magina, near Ubeda - Jaen, Spain
When the sky in a landscape photograph is weak or uninteresting it is best to include only a little of it or to exclude it altogether. It can also help to use a neutral graduated filter to make it darker.

Acting
I used a long-focus lens to isolate the most effective section of the scene, a neutral-graduated filter to make the mountainside as dark grey as possible and an 81C warm-up filter to enhance the colour of the grass.

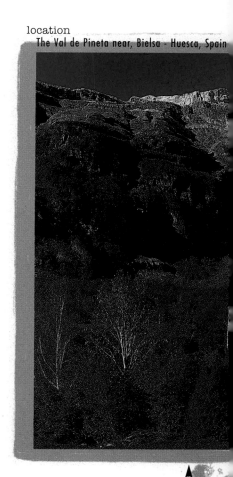

location
The Val de Pineta near, Bielsa - Huesca, Spain

Seeing

The distant snow-capped mountain creating a backdrop to the fast running river was the aspect of this scene which made me want to shoot it.

Thinking

I felt that to accentuate the impression of depth and distance would add impact to the image and that the subject needed to be framed as an upright.

Acting

I found the most effective viewpoint was from the river bed with the water flowing directly towards the camera. I used a wide-angle lens to exaggerate the perspective and to include as much foreground as possible. I used a small aperture to obtain maximum depth of field and a polarising filter to increase the colour saturation and to give the snow more definition against the blue sky.

Technical Details

6x4.5cm Single Lens Reflex - 50mm lens, polariser and 81C warm-up filters, Fuji Velvia.

Technical Details

6x4.5cm Single Lens Reflex - 55mm lens, polarising and 81C warm-up filters, Fuji Velvia.

Rule of Thumb

With landscape photographs in particular it's often an automatic choice to frame them as horizontal images but quite often a composition can be more effective as an upright image and it's a good idea to always consider this option first.

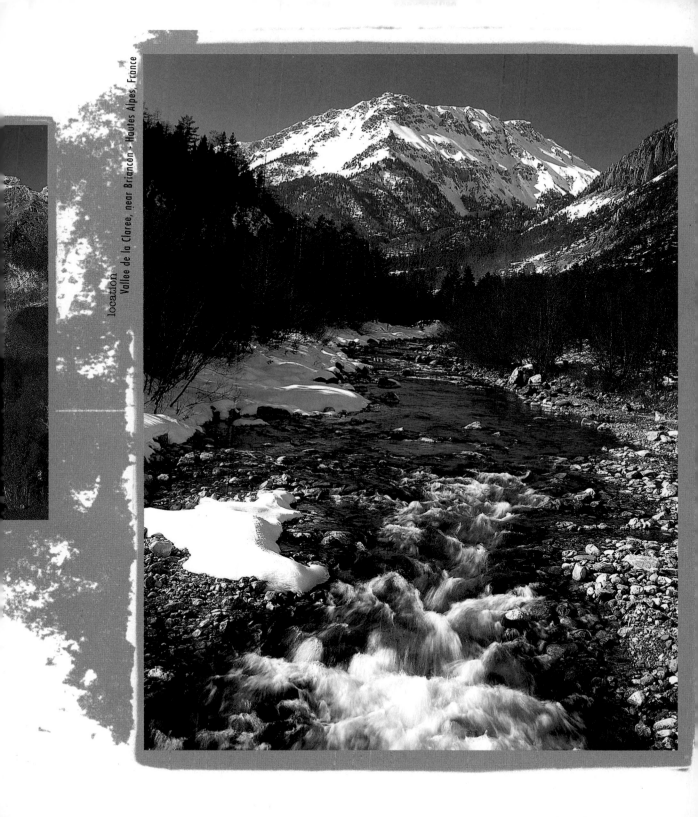

location
Vallee de la Claree, near Briancon - Hautes Alpes, France

From dark and mysterious to pale turquoise, crystal clear, rushing, motionless, sparkling and turgid, water has a constantly changing appearance which offers considerable photographic potential.

location
Lac du Der - Champagne Ardenne, France

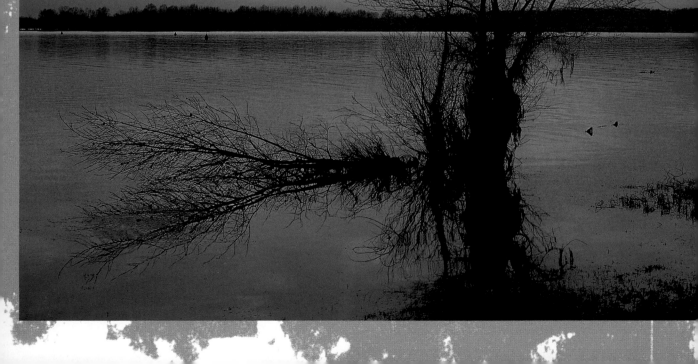

Seeing

The very still water of this lake created a mirror-like **reflection** of both the sky and the submerged tree and it was this, combined with the rich colours of the **sunset**, which appealed to me.

Thinking

I wanted to place the sun partially behind the tree to create a bold **focus of attention** and also to reduce its intensity. Because I wanted to emphasise the mirror effect I placed the horizon in the centre of the frame to divide the image into two equal halves.

Acting

I chose a viewpoint close to the lake shore so the **reflection** continued right into the **foreground** and used a wide-angle lens to include the full extent of the tree and its fallen branch, framing the shot so it created an L-shape along lines dividing the image into **thirds**.

Technical Details
6x4.5cm Single Lens Reflex - 55mm lens, Fuji Velvia.

Technical Details
6x4.5cm Single Lens Reflex - 55mm lens, neutral-graduated filter Fuji Velvia.

Rule of Thumb

When shooting pictures like sunsets and at dusk when the colours are very subtle, it's best to avoid the use of coloured filters, such as warm-ups. These can sometimes override the natural colour of the scene and create a rather artificial quality.

location
A lake
in the
Sologne,
near
Orleans -
Loire,
France

Lakes, Rivers & Waterfalls

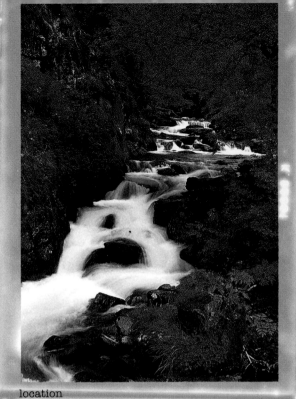

location
The Val 'Aran, near Viella - Lerida, Spain

Seeing

The canopy of fresh green foliage enclosing the small stream suggested the potential of this shot and the soft lighting and limited colour range contributed to the tranquil atmosphere.

Thinking

I wanted to emphasise the secretive quality of the scene and make the most of the water so I decided to frame the image quite tightly and use a slow shutter speed to record the moving water as a soft smoke-like blur.

Acting

I chose a viewpoint which allowed the water to create a diagonal line across the frame and used a long-focus lens to exclude all but the water and immediate foliage. In order to allow the use of a slow shutter speed I set a small aperture and also used a polarising filter to reduce the image brightness even further.

Technique

Sometimes the highlights on backlit water can be too bright to record on film and in this case I used a polarising filter to subdue them as well as helping to create a more translucent quality.

Technique

An alternative method of photographing moving water is to make a series of short exposures on to the same frame of film spaced over a period of a minute or so. If the exposure reading indicates settings of 1/8 sec at f22, for instance, you can obtain the same exposure by giving eight exposures of 1/60 sec at the same aperture or sixteen of 1/125 sec. Naturally, it is vital to use a tripod and to ensure the camera is not moved until the exposure sequence is completed.

Technical Details ↑
35mm Single Lens Reflex - 105mm lens, polariser and 81C warm-up filters 2 sec exposure on Fuji Velvia.

Technical Details →
6x4.5cm Single Lens Reflex - 55mm lens, polarising and 81C warm-up filters, Fuji Velvia.

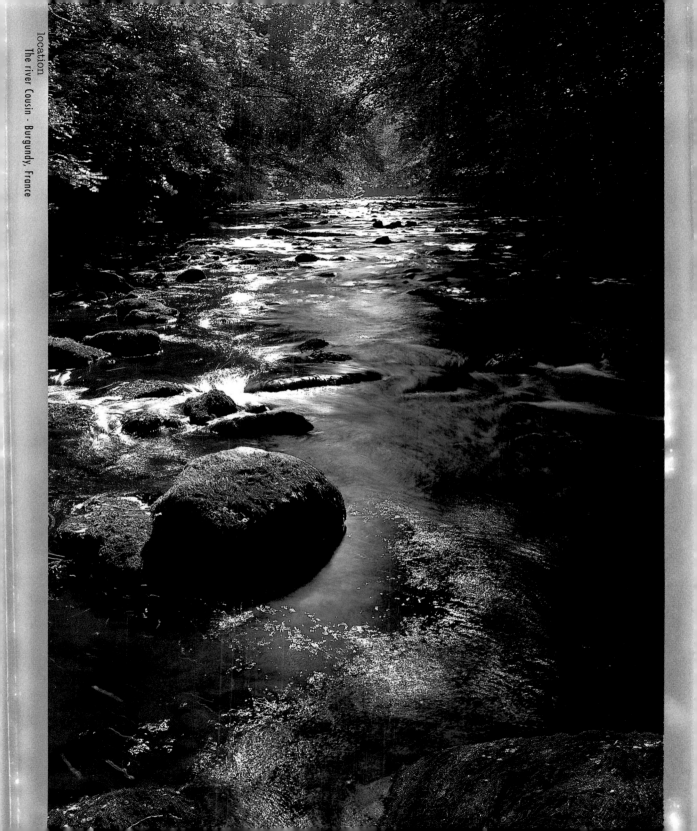

location
The river Cousin - Burgundy, France

The Coast

The coast offers a wide variety of photogenic possibilities ranging from seascapes to beach scenes, harbours, coastal villages and activities like fishing, wind surfing and sailing. In addition to photographs of broader scenes there are many pictorial possibilities to be found in places like harbours where a closer and more selective approach can produce images with a powerful graphic or abstract quality, such as details of objects like fishing boats, lobster pots and nets, which can add a considerable amount of colour and interest to the photographic coverage of a region.

Seeing

The rich colours of the sunset were the obvious attraction in this scene but I noticed that the reflections in the wet sand, combined with its texture, made the strongest contribution to the image.

It's always worth waiting when shooting sunsets as it's often more effective to wait until the sun has almost disappeared and in some cases stunning colours can be created long after it has set. A good sunset can also vary enormously in colour and quality over a period of time.

Thinking

As I wanted to maximise the effect of the reflections I decided to use a wide-angle lens and to tilt the camera down so the image was dominated by the reflection and only a small area of sky was included.

Technical Details
35mm Single Lens Reflex - 24mm lens, neutral-graduated filter, Fuji Velvia.

Technical Details
6x4.5cm Single Lens Reflex - 50mm lens, polarising and 81C warm-up filters, Fuji Velvia.

location
A beach near Cap Frehal - Brittany, France

location
The beach at Mazagon - Huelva, Spain

Acting

I chose a viewpoint which allowed me to use the line of the surf as a diagonal and waited until the brightness of the sun was subdued behind cloud before making the exposure. I also used a neutral - graduated filter to darken the sky area even more.

Rule of Thumb

A polarising filter will almost always improve the colour and quality of seascapes, even on overcast days, increasing colour saturation and making the water appear more translucent.

The Coast

Seeing

The sun rising through early morning clouds created a very striking effect in this scene but I felt the image needed some strong foreground interest so I walked along the shore to find this fishing platform.

Thinking

The sky was so much brighter than the foreground and the exposure necessary to record enough detail in the shoreline and fishing platform would have resulted in the cloud effect being over-exposed and losing the drama of the scene.

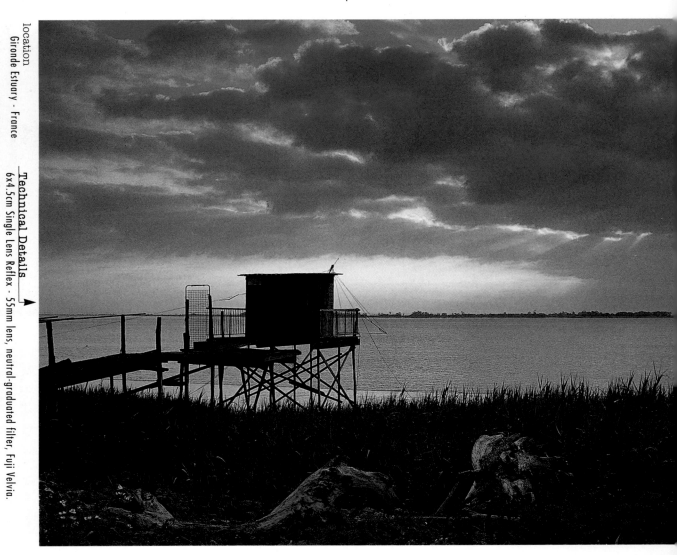

location
Gironde Estuary - France

Technical Details
6x4.5cm Single Lens Reflex - 55mm lens, neutral-graduated filter, Fuji Velvia.

When shooting subjects close to the camera it's best to use a small aperture as depth of field decreases quite considerably when the camera is focused at close distances. An image like this pile of lobster pots needs to be really sharp overall to be effective.

location
Barfleur - Normandy, France

Technical Details
6x4.5cm Single Lens Reflex - 55mm lens, 81A filter, 1/4 sec at f22, Fuji Velvia.

Acting

I chose a **viewpoint** which placed the most effective area of the sky behind the fishing platform and used a wide-angle lens to include some of the shoreline detail as well as the cloud effect. I fitted a neutral - **graduated filter** to enable me to give enough exposure to record foreground detail **without over-exposing** the sky.

When composing a shot it helps to look first at the edges of the frame rather than the centre, which is the natural reaction, as it helps you to avoid including any distracting details.

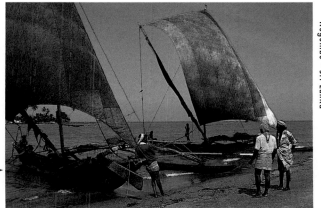

location
Negombo - Sri Lanka

Technical Details
35mm Single Lens Reflex - 35mm lens, polarising and 81C warm-up filters, Fuji Velvia.

Familiar Landmarks

Technical Details →

6x4.5cm Single Lens Reflex - 105-
210mm lens, polarising and 81C
warm-up filters, Fuji Velvia.

Photographing the world's most famous landmarks
can be a problem if only because they have been very well photographed many times before
and are familiar to all. But such images are in regular demand by editors and publishers and
a strong image of a well-known place will always find a market.

Seeing

The row of windmills lining the ridge of a hill above
the village of Consuegra are hard to miss but finding a
viewpoint which groups them into a pleasing
arrangement is a little more difficult.

Thinking

I felt that my best chance of grouping several together
was to find a viewpoint which allowed me to
shoot along the ridge. This was made more difficult
as the angle of the strong directional sunlight
created unattractive lighting effects from
some of the possible viewpoints and there was a
tarmac road quite near them which I wanted to
exclude.

Acting

I found this viewpoint by climbing onto a rocky knoll some
distance away from the windmills but found that my
210mm lens enabled me to frame them quite tightly
and also allowed me to crop out the tarmac in the immediate
foreground.

Technique

If they are Illuminated, buildings will often look more
interesting when shot at night than they do in daylight
and this can also be a very useful way of masking
problems like crowds of people, parked cars and
street signs, for instance.

Technical Details

6x4.5cm Single Lens Reflex -
105-210mm zoom lens,
81B warm-up filter, Fuji Velvia.

Technical Details →

35mm Single Lens Reflex -
28mm perspective control lens,
1/2 sec at f5.6, Fuji Provia
rated at ISO 200.

When photographing
well-known places it
often helps to give
your pictures more
impact and to avoid
the picture postcard
cliches if you shoot
when the lighting or
weather conditions
are unusual – as in
this shot of
Stonehenge taken just
before a summer
storm.

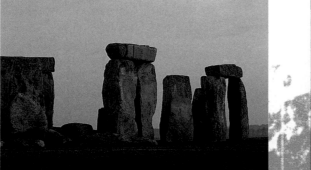

location
Stonehenge - Wiltshire, UK

location
The King's House, Market Place - Brussels, Belgium

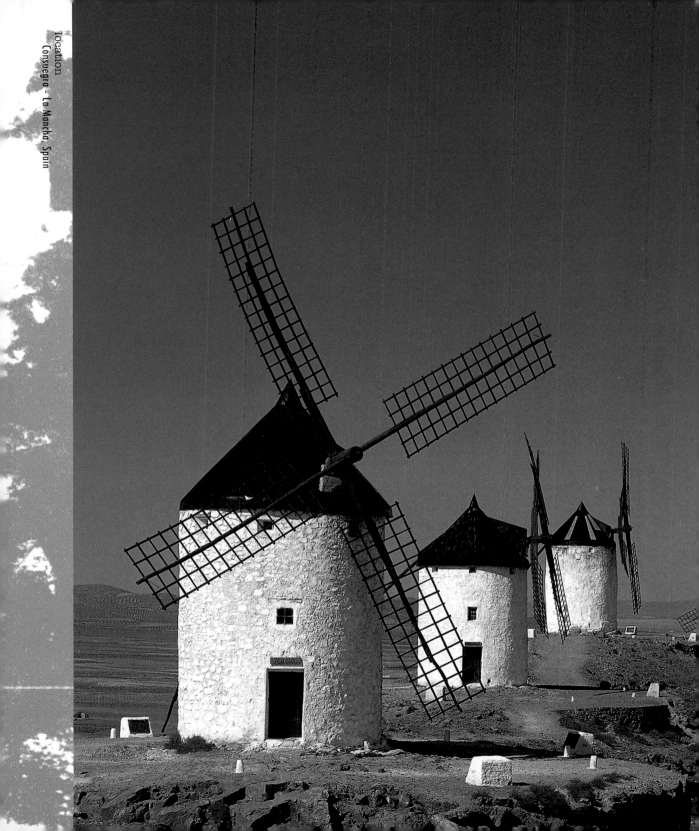

location
Lions Court, Alhambra - Granada, Spain

Rule of Thumb

A perspective control lens not only enables you to include the top of a tall building without the need to tilt the camera upwards, causing converging verticals, but it can also sometimes be effective to use it to exclude a cluttered or uninteresting foreground.

Technical Details
35mm Single Lens Reflex - 28mm perspective control lens, Fuji Velvia.

location
Taj Mahal - Agra, India

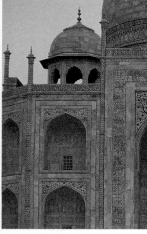

Technical Details
35mm Single Lens Reflex - 75-300mm zoom lens, 81B warm-up filter, Fuji Velvia.

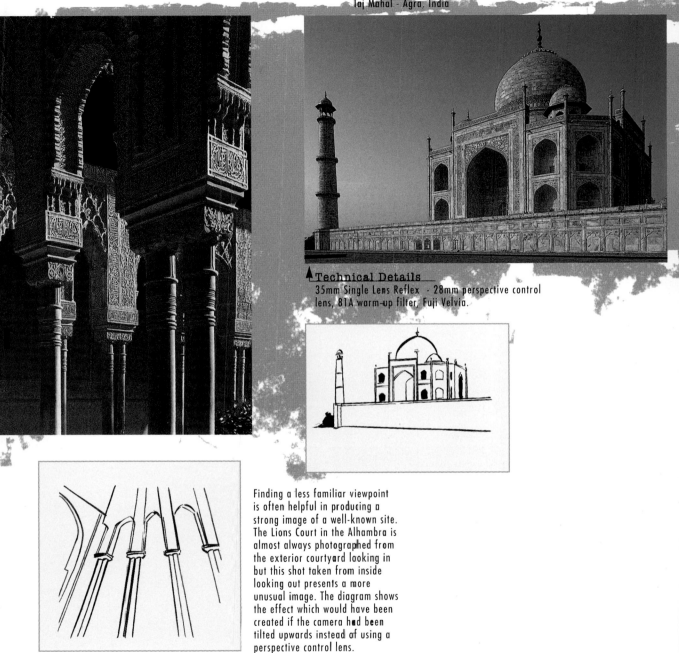

▲Technical Details

35mm Single Lens Reflex - 28mm perspective control lens, 81A warm-up filter, Fuji Velvia.

Finding a less familiar viewpoint is often helpful in producing a strong image of a well-known site. The Lions Court in the Alhambra is almost always photographed from the exterior courtyard looking in but this shot taken from inside looking out presents a more unusual image. The diagram shows the effect which would have been created if the camera had been tilted upwards instead of using a perspective control lens.

Centuries old buildings, whether they are churches, castles, palaces or simple cottages, usually have a number of things in common – ancient stonework, weathered timbers and ornate decorations. These provide the sort of visual components with which the photographic process can be used to create images with a rich, textural quality and powerful sense of form and depth.

Rule of Thumb

The colour, and texture, of old stone and timber is greatly enhanced by the warm, mellow sunlight created at the end of the day and if the building's outlook, and the chosen viewpoint permits, this is usually the best time to shoot. If using the bluer quality of light in the middle of the day is unavoidable, it can be of huge benefit to use a strong warm-up filter, like an 81C or 81EF, for example.

location
Leeds Castle - Kent, UK

Acting

I found that walking to the far side of the square I was just able to include all of the building using my 28mm **perspective control** lens with it shifted upwards, almost to its maximum extent. I also found that if I went slightly **further back** into the arcade which runs along this side of the square I could also include enough of the arch to act as a frame to the image.

Seeing

The warm quality of the evening light and its **glancing** angle across the **facade** of the building created a very striking image which I felt needed only a straightforward approach to record it successfully.

Thinking

I wanted to show the **complete** facade of the cathedral and also to photograph it front on. I felt it was necessary to avoid the **converging** verticals which would have been caused by **tilting** the camera upwards to include the top of the structure.

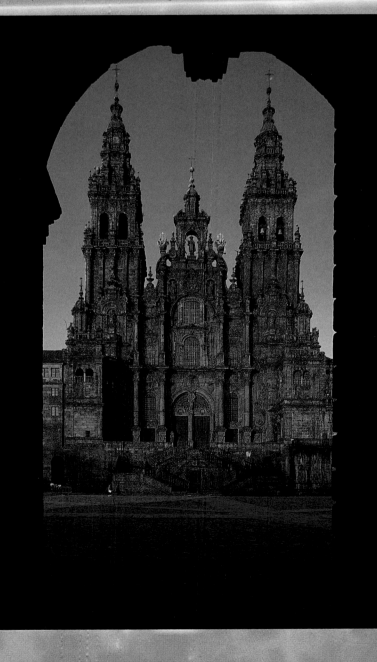

Technical Details ➤
35mm Single Lens Reflex - 28mm perspective control lens, Fuji Velvia.

◄ **Technical Details**
6x4.5cm Single Lens Reflex - 55–110 zoom lens, 81A warm-up filter, Fuji Velvia.

Historic Buildings

Rule of Thumb

While the use of deliberately tilted camera angles and exaggerated perspectives can often be effective in photographing ancient buildings it's often best to record the structure's shape and form as true to its architecture as possible. A good solution is to look for a more distant viewpoint which enables you to keep the camera level and where there are interesting foreground details which can be used to enhance the composition.

Technical Details
35mm Single Lens Reflex - 35–70mm zoom lens, neutral-graduated and 81C warm-up filters, Fuji Velvia.

Technical Details ▶
6x4.5cm Single Lens Reflex - 50mm lens, polarising and 81EF warm-up filters, Fuji Velvia.

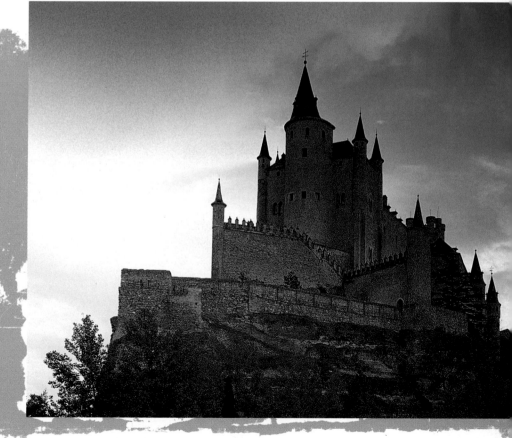

location
The Alcázar, Segovia Castile Leon, Spain

Tilting the camera up to include the top of a building and deliberately causing converging verticals can often be effective but it's best not to include the ground or horizon as this can make the building appear to be toppling backwards.

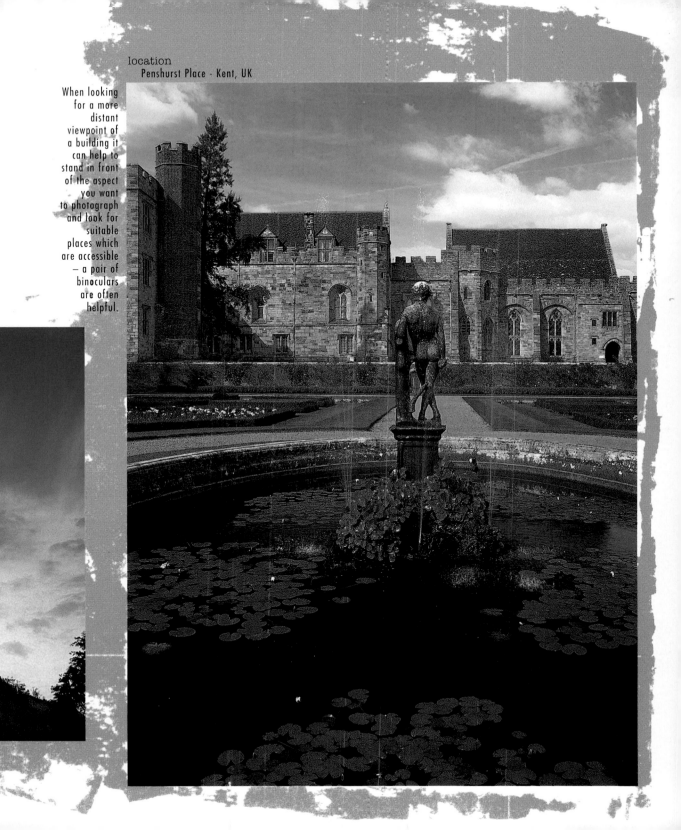

When looking for a more distant viewpoint of a building it can help to stand in front of the aspect you want to photograph and look for suitable places which are accessible – a pair of binoculars are often helpful.

Modern Architecture

Modern architecture is a dominant feature now of most large towns and cities no matter where you go in the world. Although buildings of concrete, steel and glass may lack the romantic appeal of ancient and historic buildings they do offer the photographer an opportunity to produce images with dramatic perspectives, bold patterns and a strong graphic quality.

Seeing

Looking up at these buildings towards the sun created quite a dramatic effect but it was a very contrasty scene and I could also see that the flare from the sun would be a problem.

Thinking

In order to maximise the perspective effect I decided to use my widest angle lens and shoot from a point almost immediately below the buildings so that I could tilt the camera up at a steep angle.

location
Los Angeles - USA

The use of pattern and perspective can be particularly effective in the context of modern architecture. Patterns can seem even bolder and perspective effects even more dramatic with pictures like this which have a limited colour range and soft lighting.

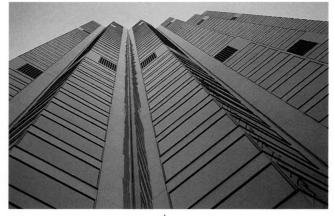

Technical Details
35mm Single Lens Reflex - 24mm lens, 81B warm-up filter, Kodachrome 64.

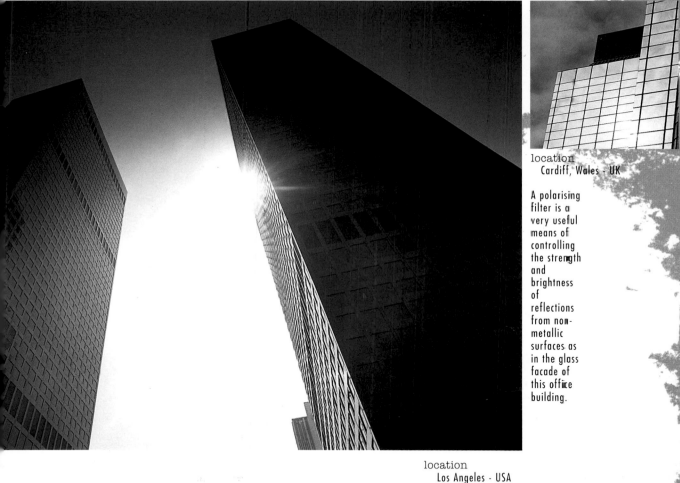

location
Cardiff, Wales - UK

A polarising filter is a very useful means of controlling the strength and brightness of reflections from non-metallic surfaces as in the glass facade of this office building.

location
Los Angeles - USA

Acting

I finely adjusted my viewpoint so the sun was partially obscured behind the building which reduced the amount of flare to an acceptable level. I also used a neutral – graduated filter to further reduce the flare and to darken the top area of the sky.

Technique

The choice of viewpoint and the time of day are vital factors in determining the way a building is lit. From a particular viewpoint the light may only be angled satisfactorily at a certain time each day and it may be necessary to make several visits. For the most part of the day the front of this diner was in shadow and it was only in late afternoon when both elevations were illuminated. A compass can be a useful aid to estimating the best time to shoot from a specific viewpoint.

Technical Details

6x4.5cm Single Lens Reflex - 50mm perspective control lens, polarising and 81B warm-up filters, Fuji Velvia.

location
Roadside diner - Massachussets, USA

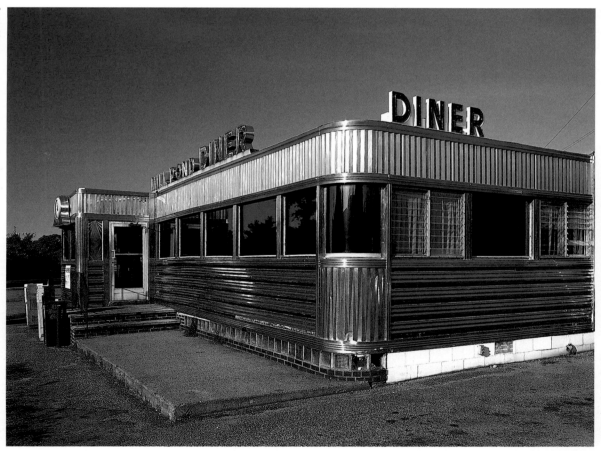

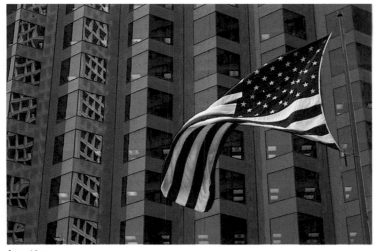

Pattern alone is seldom completely satisfying and it is more effective if there is a detail or object within the pattern which breaks it and creates a focus of interest, like this flag fluttering in front of a high-rise building, for example.

location
San Francisco - USA

Rule of Thumb

Pattern is a visual element which invariably imparts an eye-catching quality when used in a composition. Modern buildings are usually a rich source of such images and often all that is needed to exploit them is a keen eye and a long-focus lens which allows you to isolate small sections of a structure.

location
San Francisco - USA

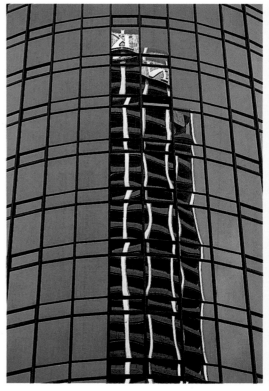

Technical Details
35mm Single Lens Reflex - 150mm lens, Kodachrome 64.

Technical Details
35mm Single Lens Reflex - 150mm lens, Kodachrome 64.

People in their Environment

While photographing subjects like the countryside, famous landmarks and historic buildings are a very important aspect of travel photography, and one which is very effective in establishing the identity of a location, it's also necessary to show something of the life and character of a country's population in order to show a full picture of a particular destination.

Rule of Thumb

When you want to photograph people within a setting, a wide-angle lens will allow you to get quite close to your subject and still include a large area of the background. But you do need to choose a viewpoint and frame the image carefully to ensure the composition is well balanced and there are no conflicting details.

location
Negombo - Sri Lanka

Technical Details
35mm Single Lens Reflex - 35mm lens polarising and 81C warm-up filters, Fuji Velvia.

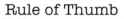

Seeing

This scene, of a Masai village, was a very **colourful** situation with many people jostling around a small square in front of a row of shanty-town shops. There was strong **overhead sunlight** which tended to make the vividly dressed Masai become an unmanageable **jumble** of colour and detail.

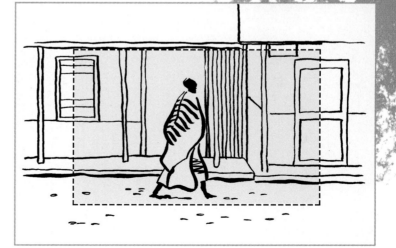

location
Amboseli - Kenya

Thinking

Because of this I decided to use a fairly **distant** viewpoint with a long-focus lens to **isolate** small areas of the scene and to enable me to focus attention on various individuals instead of attempting to record a wider view.

Acting

I chose a **viewpoint** and framed the image so that a dark and fairly **featureless** area of the scene acted as a **background** and then simply waited until a suitable subject moved into the right position.

People in their Environment

Rule of Thumb

When using an autofocus camera and the subject is off-centred and closer to the camera than the rest of the image, as in this case, be sure to focus on the most important part of the image, lock the focus and then reframe as required before exposing.

Seeing

The fruit barrow with its vendors were what caught my eye in the first instance in this street scene, but I also liked the doorway behind them.

Thinking

I felt that I needed to include the whole of the doorway if I were to use it as a background but the street was quite narrow which meant I had to use a wide-angle lens and tilting it would cause converging verticals.

Acting

Fortunately, there were some steps on the opposite side of the street and this raised viewpoint allowed me to include the entire doorway without having to tilt the camera very much.

Technical Details
35mm Single Lens Reflex - 24mm lens, 81B warm-up filter, Fuji Provia.

Technique

A wide-angle lens is the obvious choice for shots where you want to include a large area of a scene as a background to your subject, but you do need to be careful of the potential conflict between subject and background. An effective way of dealing with this is to view the background or setting as a self-contained image which has a gap into which, by careful choice of viewpoint, the person or people can be placed.

location
Kandy market - Sri Lanka

Technical Details
35mm Single Lens Reflex - 35-70mm zoom lens, Fuji Provia.

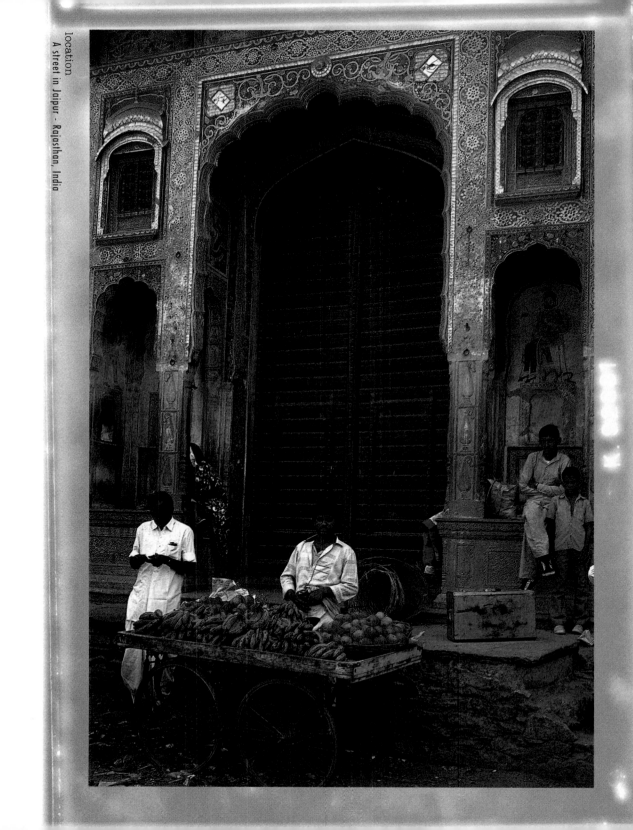

Trees & Plants

The photography of local flora is something which needs a rather different approach to most general travel subjects but is an effective way of adding an extra dimension to the coverage of a region as well as providing both variety and interest to a collection of photographs. In many cases, shots of this type can do a great deal towards helping to create a sense of place and in conveying the character and atmosphere of a particular country.

Rule of Thumb

When photographing blooms and foliage you will find that a polarising filter will often increase the colour saturation considerably and in some cases, as in this shot of Bougainvillea, help to render a difficult colour more accurately.

location
Bougainvillea - Andalucía, Spain

Seeing

Late evening sunlight illuminated this Acacia tree from the side throwing its skeletal branches into stark relief and a dark stormy sky behind gave it additional impact and drama.

Thinking

I felt the picture would be most effective if I could isolate the tree as much as possible from its surroundings and frame it tightly to emphasise the bold shapes created by its trunks and branches.

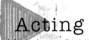

Acting

I found a viewpoint from which there was a clear gap between the trees on each side of my subject and used a long-focus lens to exclude them from the frame. I gave a half-stop exposure less than indicated to maximise the contrast between the dark sky and the brightly lit tree.

Technical Details
35mm Single Lens Reflex - 35–70mm zoom lens, polarising and 81B warm-up filters, Fuji Velvia.

Technical Details
35mm Single Lens Reflex - 80–200mm zoom lens, 81C warm-up filter, Fuji Provia.

location
Acacia Tree - Nakuru, Kenya

location
Spring crocus, Wensleydale - Yorkshire, UK

Technical Details →
35mm Single Lens Reflex - 75–150mm zoom
lens, extension tube, Fuji Velvia.

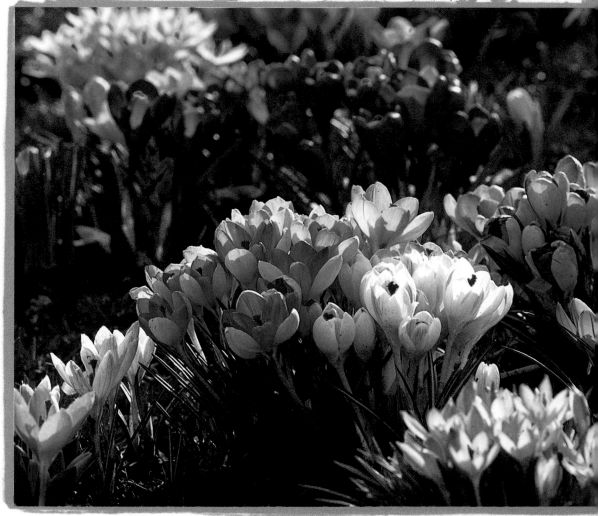

location
Fig plant - Sri Lanka

Technique

When a subject has a bold or interesting texture, like this leaf with water droplets, it can be very effective to get really close to the subject in order to reveal the very smallest details. But at this degree of close-up the slightest camera movement will cause the image to become blurred and it is necessary to use a tripod

Rule of Thumb

The bright sunlight in this shot created high contrast with bright highlights and dense shadows which are best avoided for colourful close-up photographs. In these situations, shooting against the light will often produce a more pleasing quality.

Technical Details

6x4.5cm Single Lens Reflex - 10s—ww210 zoom lens, extension tube, 1/8 sec at f16, Fuji Velvia.

Special Situations

Exposure, Sunlight, Diaphragm	3,5	4,5	5,6	8	11
Sport Scenes	1/500		1/300	1/150	
Sea Shore, High Mountains			1/300	1/150	
Bright Streets, Squares	1/500		1/300	1/100	1/50
Landscape distant views					
„ w. dark foreground	1/300	1/100	1/50	1/25	1/10
Street Scenes		1/300		1/100	1/50
Groups in open air					
„ under bright trees	1/100		1/50	1/25	
„ in light interior					
HRS 9-3 May,					
Double { March,					
Exposure { Light or U. V. Filter or no sun.					

There are some situations which obviously demand
a special approach – shooting indoors for example, or on safari. However, there are other
occasions that also require careful thought which you may not have considered before, such
as shooting in crowded places, dealing with close-ups or shooting
photo essays. Find out how to approach all these and more.

2

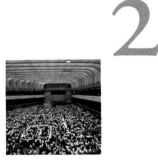

Photographing Interiors

Taking photographs of interiors is something a travel photographer sometimes needs to do and they can often prove to be more interesting and photogenic than exterior shots. But such pictures can present a number of special problems. A great deal depends upon the way the space is lit. Many buildings, like churches and cathedrals for instance, have what seems to be a very dimly lit interior, often with just the natural daylight which filters through the windows. Providing this is fairly evenly distributed, the low level of illumination need not be a problem, as a camera mounted on a tripod can be given as long an exposure as necessary.

Seeing

The altarpiece was the obvious focus point in this interior and I thought it would be most effective to place it in the centre of the image and go for a symmetrical composition.

Thinking

The church was lit by a mixture of daylight from the windows and artificial light. Although I thought the latter would probably be dominant I opted for daylight film as I would prefer the shot to have a warm quality rather than a bluish one.

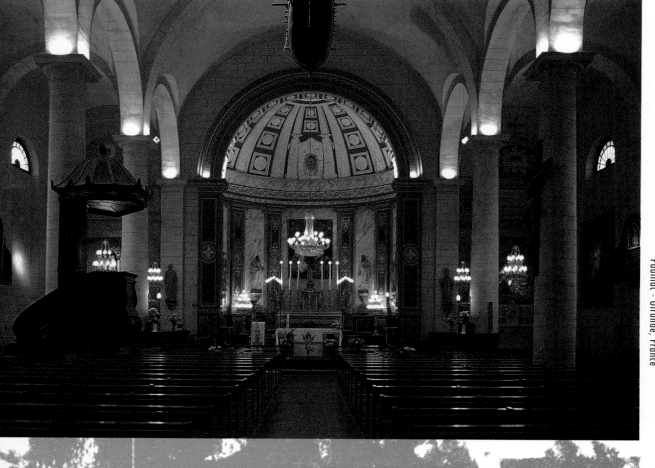

location
Pauillac - Gironde, France

location
La Mezquita, Córdoba - Andaluciá, Spain

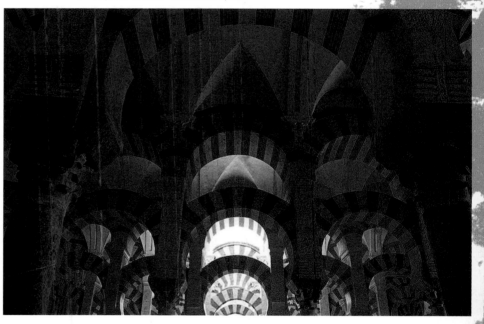

Acting

I used a **perspective control** lens as the foreground lacked interest and I did not want to tilt the camera and have **converging** verticals. I fitted a blue 82B filter to prevent the artificial light from creating an excessively strong orange cast on the daylight film.

Rule of Thumb

A good way of judging just how evenly, or otherwise, the space is lit to view the scene through half-closed eyes, this will readily show if there is a big difference between the lighter and darker areas of the interior. Alternatively you can view the subject through the camera with the lens stopped down using the depth-of-field preview button.

Technical Details
35mm Single Lens Reflex - 28mm perspective control lens, 82B filter, 12secs at f8, Kodak Ektachrome E100S.

Technical Details
35mm Single Lens Reflex - 35-70mm zoom lens, 2 secs at f5.6, Fuji Provia.

Seeing

It was the vastness of this interior, photographed from a first floor gallery, which first impressed me but the mass of brokers filling the floor was equally striking.

Thinking

My first thought, and action, was to shoot on a wide-angle lens using horizontal format. But the most crowded part of the floor was in the centre and the impact of the mass of people seemed greater if I framed the image more tightly.

Acting

I switched to a lens with a narrower field of view and changed to an upright format in order to exclude the less crowded edges of the image. As the interior lighting was of a completely unknown quality I opted to use daylight film with no filter but the resulting image has a greenish cast which, in retrospect, I would have preferred to have corrected.

Technique

When a subject is lit by predominately fluorescent lighting it is best to shoot on daylight film using a magenta-tinted filter. The strength of the filter needed depends upon the precise nature of the fluorescent tube but a fairly safe bet is to use an FLD conversion filter.

location
Stock Exchange - Tokyo, Japan

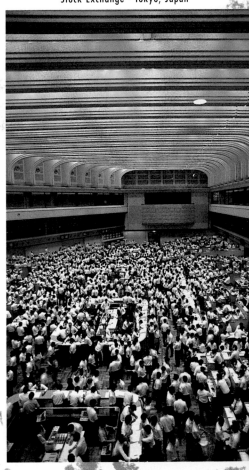

Technical Details
35mm Single Lens Reflex - 35mm lens,
T sec at f5.6, Kodak High Speed Ektachrome.

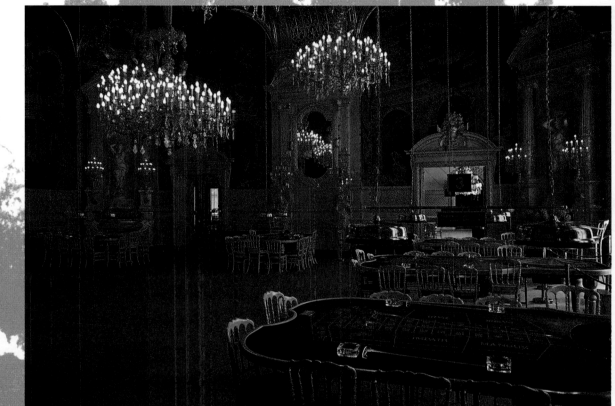

location
The casino, Baden Baden - Germany

Technical Details
35mm Single Lens Reflex - 35mm lens, 1/4
sec at f14, High Speed Ektachrome.

Rule of Thumb

When confronted with mixed
lighting, or lighting of an
unknown colour quality it is
safer to shoot on colour
negative film as this is more
tolerant of colour temperature
variations and the image can
be easily corrected at the
printing stage.

Events & Occasions

One of the pleasures of travelling is that of encountering local events such as festivals, folk customs and street parades. Successful photography of occasions like these depend a great deal upon securing a good vantage point. At these events you will benefit enormously from an early arrival and good reconnaissance. It also helps to talk to officials in order to discover where the best positions might be and when the most exciting parts of the proceedings will take place.

Seeing
The action is of course the main point of a shot like this but I also wanted to capture something of the setting and atmosphere of the occasion.

Thinking
This particular event meant that the most dramatic part of the action took place at a fairly predictable point – where the horse was first released from its pen – and it often lasted for only a few seconds before the cowboy was removed.

Acting
I walked around the edge of the arena looking for a viewpoint where I had a clear view of the horse emerging but also was able to include a little of the setting itself.

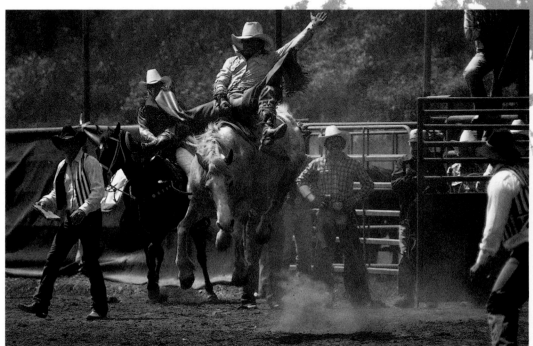

location
Rodeo, California - USA

location
Traditional theatre - Bali

Technical Details
6x4.5cm Single Lens Reflex - 105mm lens,
125 sec at f4,
Fuji Provia rated at ISO 200.

Technical Details
35mm Single Lens Reflex -
300mm lens,
1/500 sec at f5.6,
Kodak High Speed
Ektachrome.

Technique

When shooting in low light and a fast shutter speed is needed it is possible to rate the film at one or two stops faster than its stated speed and to ask the processing laboratory to push process the film by one or two stops respectively.

Shooting Unobserved

Photographing people when they are unaware of the camera can be an important and very effective part of travel photography but is also one of the most difficult things to do successfully, especially when working in an alien culture where the presence of a stranger can be a noteworthy event. This type of photography is easiest to achieve when your subjects are preoccupied with some activity and surrounded by others, such as at a market or in a busy street.

Seeing
This lady seemed to be an ideal subject because she was nicely posed against a plain, uncluttered background and the pile of baskets added interest and balance to the composition.

Thinking
As I did not want to shoot her looking into the camera I chose my viewpoint so she was nicely placed against the background and then directed my attention away from her pretending to shoot pictures elsewhere.

location
Street market - Bali

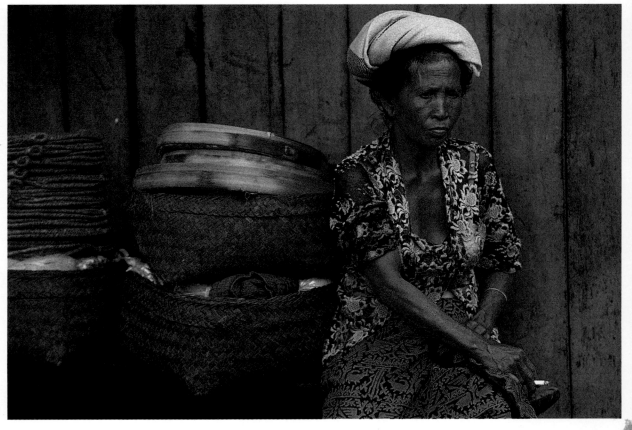

A zoom lens is very useful for shots like this as you can adjust the way the image is framed without having to change your viewpoint and risk attracting your subject's attention.

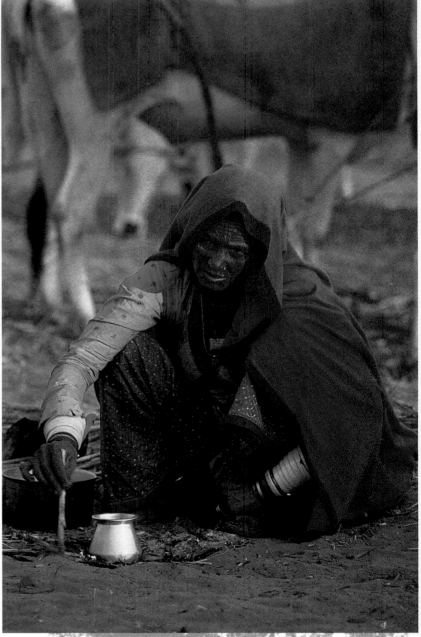

Rule of Thumb

If you get caught red-handed trying to shoot a candid of someone it's far better to just smile and say, or mime 'I hope you don't mind' than to turn away. Few people will be offended if you use a little charm and you can often get the chance to shoot another picture with their co-operation.

Acting

The moment her interest in me waned and she became preoccupied with other things I quickly re-aimed the camera and made my exposures, having pre-set the exposure and focusing.

location
Pushkar camel fair - Rajasthan, India

Technical Details
35mm Single Lens Reflex - 105mm lens, Fuji Provia.

Technical Details
35mm Single Lens Reflex - 70–210mm lens, Fuji Provia.

Photography on Safari

Taking photographs while on safari is quite different to most other types of photography and needs a rather different approach as well as the use of different techniques. Within the national game parks, where most safari trips take place, it is generally forbidden to leave the vehicle and this in itself requires a fairly radical change to the way photographs are normally taken. Choosing a viewpoint is largely a question of ensuring the vehicle is in the right place and you are in the best position within it.

Seeing
This young zebra had a very obvious **appeal** and it's closeness to its parent suggested there might be a way of photographing them together.

Thinking
I felt a very **tightly framed** shot would give the image additional impact and would also emphasise the striking **pattern** created by their striped bodies.

location
Young zebra, Masai Mara - Kenya

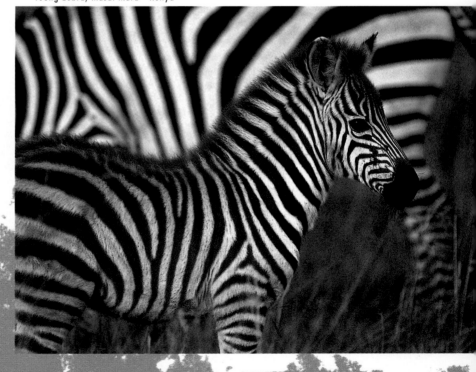

When using long focus lenses it is vital to have some form of support to avoid the risk of camera shake. In a vehicle, a bean bag rested on the window frame or roof hatch is ideal. Alternatively, you can buy a bracket which clamps on to the window and a monopod is also a useful form of support when a tripod can't be used.

Acting

I asked the Landrover driver to get as close as he could and fitted the 600mm lens to give me a very close-up image. It was also necessary to drive very slowly and quietly to one side of the zebras to obtain the most effective juxtaposition between their two bodies.

Technical Details
35mm Single Lens Reflex - 600mm lens, 1/500 sec at f4, Fuji Provia.

Technical Details
35mm Single Lens Reflex - 600mm lens, 1/250 sec at f4, Fuji Provia.

location
Waterbuck - Nakuru, Kenya

Photography on Safari

Rule of Thumb

Where possible, try to set the subject against a fairly plain, contrasting tone or colour and avoid the presence of distracting highlights or details behind the animal or bird.

Seeing

The bold markings of this giraffe were emphasised by the warm colour of the sunlight in the late afternoon and as the animal was on the move, I felt it might produce a strong image.

Thinking

I asked the driver to move slowly ahead of the animal until I found an area of fairly plain background across which I thought it would travel.

Acting

I followed the animal in my viewfinder as it approached, keeping it in focus and waiting until it moved into the best position before making my exposures. It was just a happy chance that, at this moment, the giraffe leaned forward to create this nice shape.

Technical Details →
35mm Single Lens Reflex -
600mm lens, 1/500 sec at f4,
Fuji Provia.

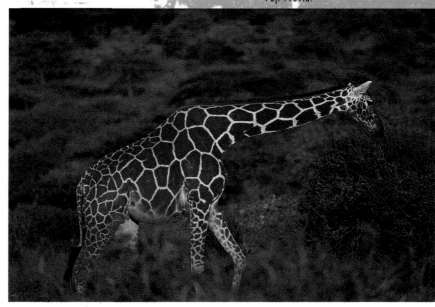

location
Reticulated
Giraffe -
Samburu,
Kenya

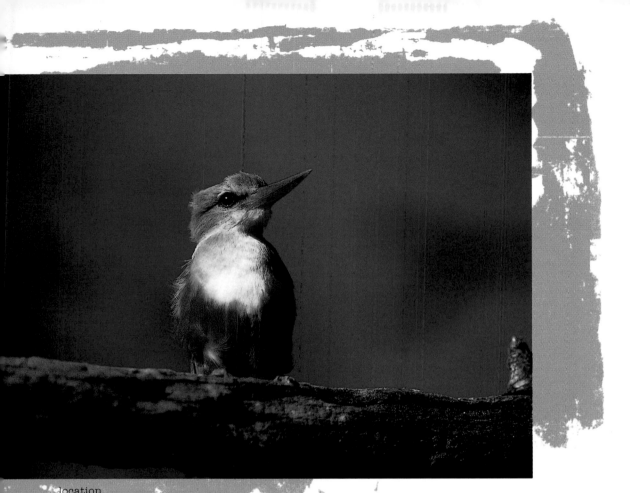

location
Kingfisher - Samburu, Kenya

Technique

Getting close enough to your subject is the first concern when choosing a viewpoint but it's also necessary to consider the lighting. In bright sunlight the contrast can easily create an unattractive quality in photographs with dense shadows and burned out highlights and the choice of viewpoint can be a vital factor if this problem is to be avoided.

Technical Details
35mm Single Lens Reflex -
150–500mm zoom lens,
1/250 sec at f5.6, Fuji Provia.

Close-up Photography

With the majority of photographs, the lens is focused at a distance of two metres or more but when a closer view of a subject is needed, and the focusing distance is significantly closer than this, there are a number of special considerations to be made. One metre or so is the usual close-focusing limit of normal lenses but there are several ways of reducing this limit. Many ordinary zoom lenses now have a macro setting which will allow it to be focused down to a few inches but this is often only at one setting of the zoom's focal length.

Seeing

These grapes have developed 'noble rot' an important stage in the production of the famous sweet desert wine, Monbazillac. It was necessary to use a very close-up image in order to show the appearance of the fruit.

Thinking

I felt a very straightforward approach would be best and that a flat on-shot of the grapes in their trug would show the texture and colour most effectively.

Acting

I moved the trug into the shade to ensure the lighting was soft and there were no strong shadows or bright highlights and set my tripod so I could aim the camera straight down on to the grapes. I placed a few vine leaves to add interest to the composition and set a small aperture to ensure adequate depth of field.

Technique

Lighting quality is an important factor with many close-up subjects, as subtleties of colour and texture can easily be obscured by areas of shadow. With close ups, like this shot of fruit, it's a simple matter to use a reflector or fill-in flash to throw light into the shadows.

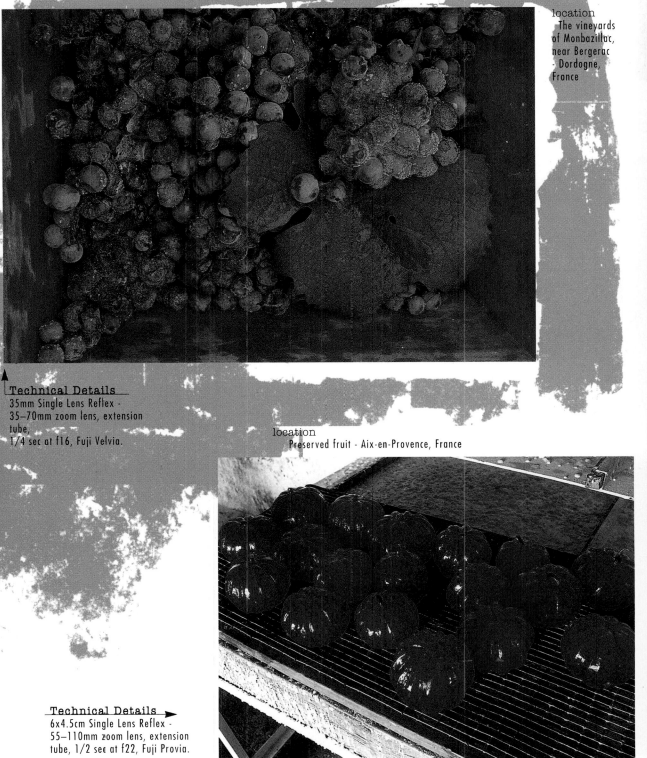

location
 The vineyards
of Monbazillac,
near Bergerac
- Dordogne,
France

Technical Details
35mm Single Lens Reflex -
35–70mm zoom lens, extension
tube,
1/4 sec at f16, Fuji Velvia.

location
 Preserved fruit - Aix-en-Provence, France

Technical Details
6x4.5cm Single Lens Reflex -
55–110mm zoom lens, extension
tube, 1/2 sec at f22, Fuji Provia.

Informal Portraits

While taking shots of people while they are unaware of the camera can produce spontaneous and natural images there are occasions when it can be better to ask their permission and have your subject's co-operation. Before you do so, think about the best place to place them and how they should be posed as you will then be able to work more positively and quickly which helps to make your subject more at ease.

Seeing

I saw this marvellous character loading his cart as I drove past and felt he would make a great subject, especially as the background was also ideal and would contribute to the atmosphere and composition of the shot.

location
Alsace - France

location
Muscadet vineyards - Loire, France

Technique

Having your subject **seated** tends to be best for portraits in general – on a wall, tree trunk or even on the ground is preferable to standing. It can help when the model is able to sit in such a way that he or she can lean forward to **support** arms or elbows on something as this makes for a more **relaxed** and **natural** picture.

Technical Details
35mm Single Lens Reflex - 35–70mm zoom lens, Fuji Provia.

Thinking

It was obvious I needed to ask **permission** as he had already noticed me stop and was doubtless wondering what I wanted. I felt I might as well go a stage further and ask him to take up a **position** beside the cart – he was very happy to oblige.

Acting

Placing his arm on the cart **linked** the two elements together very well and also helped him to feel more relaxed. I used a **wide-angle** lens so that I could get quite close to him but, at the same time, include enough of the **background** and cart to establish the **setting**.

Technical Details
35mm Single Lens Reflex - 35–70mm zoom lens, Fuji Velvia.

Technical Details
35mm Single Lens Reflex -
80–200mm zoom lens, Fuji Provia.

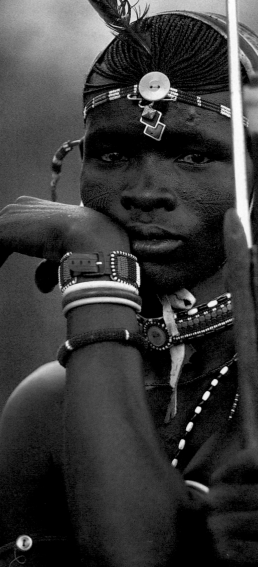

Seeing
I saw this handsome man among a group of dancers in a Samburu village and felt he would make a good subject for a striking portrait. It was a bright sunny day making the colours and textures of the scene became rather confused and distracting

I shot this full-length portrait on a long-focus lens using a fairly distant viewpoint so that I could select a small area of the scene to act as a background as well as creating a more interesting perspective.

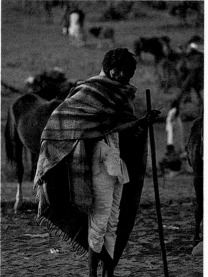

location
Pushkar camel fair - Rajasthan, India

location
Samburu tribesman - Kenya

Thinking

There was a group of trees to one side of the area where the dancers were performing and I thought the shade they provided would create a more pleasing lighting quality for a head-and-shoulder portrait.

Acting

I picked out a spot where the background was fairly unobtrusive and waited until the performance had ended before approaching my subject. I asked him to move into the spot I'd picked and suggested he lean on his spear to create a nice shape and make him appear relaxed. I used a long-focus lens to frame the image quite tightly and set a wide aperture to ensure the background details were out of focus.

Technique

Direct sunlight can often create an unattractive quality with portraits and shooting into the light, with the sun behind the subject, is often a better option. But it does need some care. It is important to ensure that the sunlight does not fall directly upon the lens as this can cause flare and degrade the image. It's also necessary to increase the exposure indicated by an average reading, or to take a close-up or spot reading from a mid tone within the subject.

Technical Details
35mm Single Lens Reflex - 75–300mm zoom lens, 1/500 sec at f5.6, Fuji Provia.

Technical Details
35mm Single Lens Reflex - 35mm lens, Fuji Provia.

location
Jaipur - Rajasthan, India

Shooting a Photo Essay

The majority of photographs are taken with the intention of standing alone, to be viewed as single, independant images. But this can be a rather limiting way of regarding photography and often the desire to include as much information as possible during that single decisive moment, when the exposure is made, is the biggest factor in producing photographs which have little visual appeal and impact.

While some images are powerful enough to stand alone, hung on a gallery wall, for example, or used as a magazine cover or double-page spread, they often do not tell the viewer as much about the place or subject as a sequence of images can in the form of a photo essay.

The key to shooting a photo story is the ability to think in terms of how the images you are producing will look when viewed as a collection, as they might be laid out on a double-page spread of a magazine, for instance. The main thing is to consider how each picture affects the ones adjacent to it and vice versa.

location
The wine harvest - France

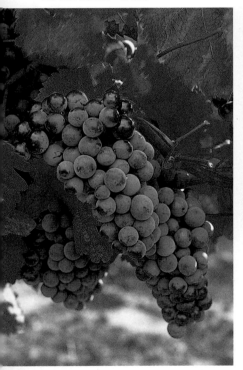

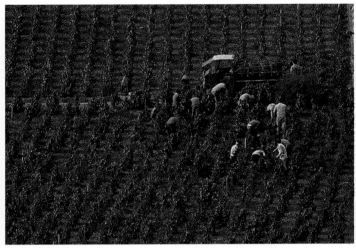

Technique

There are essentially two ways of shooting a photo essay, one is to produce a chronological coverage of an event in a recognisable sequence and the other is to build up a composite image of a place by photographing a series of isolated aspects of a location and linking them together.

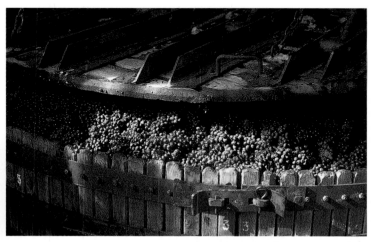

◄ **Technical Details** ►
35mm Single Lens Reflex -
various lenses,
Fuji Provia and Velvia.

Technique

It also helps to vary the
colour quality and
content of your shots so that
some images are bold and
fully saturated and
others have a softer and
more pastel quality. You can
also vary the subject matter
of your photographs so that a
shot of a building is seen in
sequence with say a
portrait or a landscape.

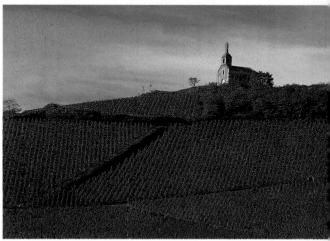

Composition & Light

3

It's vital to devote time to the
technical aspects of taking pictures —
finding the right viewpoint, composing the subject well and waiting until the light is at its most
evocative. Sometimes it's not the most obvious approaches which produce the best pictures —
as you will see in this chapter.

Using Shapes & Patterns

Photographs depend for their effect on a number of individual visual elements and the most successful photographs are usually those in which one or more of these elements is boldly and clearly defined. The outline or shape of a subject is the element which usually first identifies it and a photograph with a boldly-defined shape invariably has a strong impact. Subjects which contain a simple, basic shape like a circle or triangle are often among those which create the most eye-catching images.

Seeing

The very dominant colour and interesting shapes of these shuttered windows caught my eye while travelling through a French village. Even the creeper had a strong shape and colour and the neutral background made a good contrast for both.

Thinking

I wanted to frame the image as tightly as possible, to emphasise the shapes and colour and also to exclude adjacent details which would have spoiled the balance of the image.

Technical Details →
35mm Single Lens Reflex - 150mm lens, 81B warm-up filter, Fuji Velvia.

← **Technical Details**
35mm Single Lens Reflex - 50mm lens, Kodak Ektachrome 64.

Rule of Thumb

When shooting on colour print film it's not worth using warm-up filters. The effect of a polarising filter will be beneficial with both types of film.
There are two types of polarising filter – Linear and Circular – and the former can cause interference with some auto-focus and exposure-control systems. If in doubt, buy a circular polariser.

location
Street Market - Marrakesh, Morocco

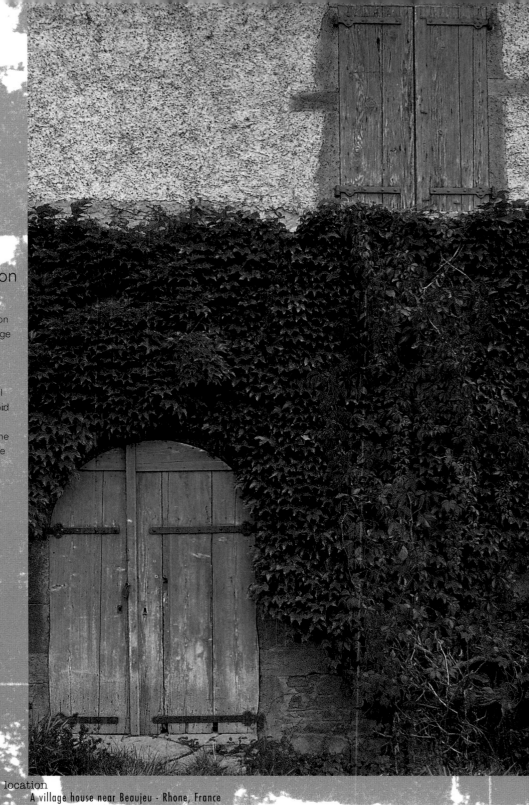

Acting
I used a long-focus lens to isolate the section of the house which made the most effective composition and framed the image so that a shutter appeared in each corner, creating a diagonal line. I used a tripod to avoid the risk of camera shake and to help me frame the image very precisely.

location
A village house near Beaujeu - Rhone, France

Using Shapes & Patterns

The impression of a pattern is created when a distinctive shape is repeated within the image and it can have a powerful impact when used as part of a composition. The effect of a pattern is most telling when there is an element within the image which creates a contrast with it, such as the le Café lettering among the shapes created by these shuttered windows.

Seeing

The **shapes** of the trees and the **pattern** created by the rows of vines had, I felt, the potential for a strong image. The effect was helped considerably by the fact that the trees were **silhouetted** against a lighter-toned **background** and the vines formed lines running directly towards them.

Thinking

The most telling part of the scene was actually quite a **small area** of the overall view and I thought the photograph would have more **impact** if I excluded the sky, which was quite **pale** and hazy.

Acting

Because of this I decided to use a very **long-focus** lens to **isolate** the most effective part of the scene. I fitted a **polarising filter** to increase the colour saturation of the foliage and a warm-up filter to further enhance the green of the vines.

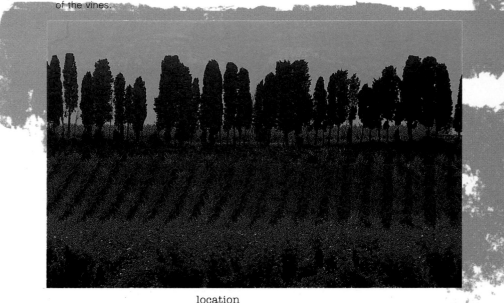

location
Vineyards near Carcassonne - Languedoc Roussillon, France

Technical Details
35mm Single Lens Reflex -
80–200mm zoom lens, Fuji Velvia.

CAFE

COLLOMBIER

location
Mauriac - Auvergne, France

Technical Details
35mm Single Lens Reflex - 300mm lens,
polarising and 81C warm-up filters,
Fuji Velvia.

Technique

When shooting subjects like this on a long-focus lens it is vital to use a tripod and cable release to obtain maximum image sharpness and it is also preferable to lock the camera's mirror up a few seconds before making the exposure so that the vibration caused as it flips up will not affect the image sharpness.

Form & Texture

The element of form gives the image a feeling of solidity and is dependent upon the direction and quality of light. A soft directional light will create a gradual transition of tone within the subject from highlight to shadow whereas a hard light will produce a more abrupt graduation from light to dark.

Seeing

It was the rich texture of this old stone wall which first caught my eye emphasised by the strong sunlight glancing along its surface from the side. But I also liked the contrasting V shape of the roof with the circular wheel.

Thinking

I felt that the most striking effect would be created by shooting the wall front-on and framing the image so the roof was at the top of the frame and the base of the wheel at the bottom.

Acting

I also wanted to reduce the effect of perspective making the wall appear as flat as possible to the camera so I used a fairly distant viewpoint and fitted a long-focus zoom lens to frame the image precisely.

location
The Cathedral of Villefranche de Rouergue - Midi Pyrenees, France

In this shot of a medieval carving the quite soft light from a window is directed fairly acutely from one side of the subject and created a full range of tones from highlight to shadow making it look solid and three-dimensional.

Texture is an element which is, in effect, the form within a surface, like a weathered stone wall, for instance and can be used to create images with rich tones and a strong tactile sense. As a general rule, the effect of texture is strongest when the light is directed from a fairly acute angle to the surface.

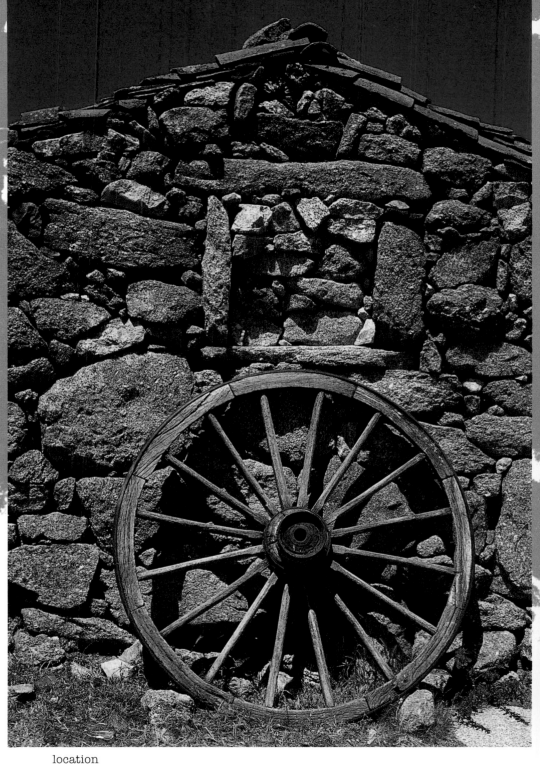

Technical
Details →
35mm Single Lens
Reflex - 75–150mm
lens, 81C warm-up
and polarising filters,
Fuji Velvia.

Technical
Details
6x4.5cm Single Lens
Reflex - 105-210
zoom lens, 4 secs at
f11, Fuji Provia.

location
An ancient farm near Avila - Castile Leon, Spain

Perspective is the effect created by the diminishing size of objects as they recede from the camera, such as looking down a tree-lined avenue, for instance. It's a valuable way of helping to give an image a sense of depth and distance and also contributes to the impression of solidity and the three-dimensional quality which a photograph can have.

Seeing

It was the quality of evening light on this seascape and the effect which it had on the colours and textures of the old weathered groyne supports and the shingle which attracted me to it.

Thinking

I considered a number of options concerning the viewpoint but finally thought that shooting along the row of posts and exaggerating the perspective might add interest to the seascape, as well as creating a more dynamic composition.

Rule of Thumb

The effect of perspective varies according to the relative distances between the camera, the nearest objects and those furthest away. If the image includes both foreground objects along with distant ones the perspective effect will be marked, so that, for instance, a person can appear much larger than a distant building. But if there is no immediate foreground and all the principle objects are some distance away from the camera there will be a minimal suggestion of perspective and objects will be shown close to their true relative size.

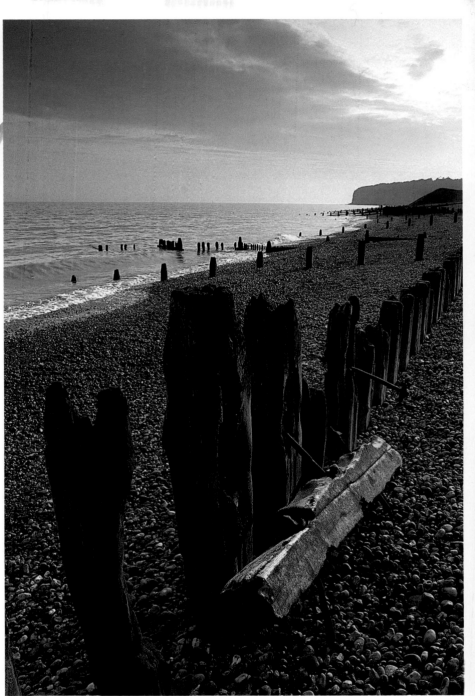

location
Death Valley - California, USA

Technical Details
35mm Single Lens Reflex -
300mm lens, 81C warm-up and
neutral-graduated filters,
Kodak Ektachrome 64.

Technical Details ➡
35mm Single Lens Reflex -
20mm lens, neutral-graduated filter,
1/4 sec 2 f22, Fuji Velvia.

Acting

I chose a viewpoint a little to the
landward side of the posts so that
I could see **along** the row and
also across them to the **sea**. I
fitted my **widest** angle lens
and moved the camera as
close as I could to the nearest
post in order to accentuate the **perspective** as much as
possible. I set the smallest possible aperture to ensure the image
was **sharp** from the nearest to the furthest detail and I fitted a
neutrall-graduated filter to make the sky a little darker.

location
Winchelsea Beach - East Sussex, UK

Seeing

Looking down from a high viewpoint revealed the pattern created by the rooftops of these village houses and this was the element of the scene which most appealed to me.

Thinking

I considered including some of the hillside and sky on the far side of the village but ultimately decided that the most striking effect would be to frame the image tightly with a long focus lens and minimise the perspective effect making the image seem to be on one plane.

Acting

I chose a viewpoint very close to the edge of the hill which enabled me to shoot directly down to exclude the foreground and framed the image so the shapes of the rooftops and white house fronts created the most pleasing arrangement.

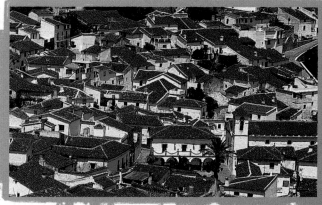

location
Algatocin - Andalucia, Spain

Technical Details
6x4.5cm Single Lens Reflex -
200mm lens, 81C warm-up
filter, Fuji Velvia.

Technical Details
35mm Single Lens Reflex -
20mm lens, polarising and 81C
warm-up filters, Fuji Velvia.

Rule of Thumb

The use of a wide-angle lens when close foreground details are included in the frame helps to make pictures taken from both high and low viewpoints more dramatic, as in this shot of fishermen photographed from close to ground level.

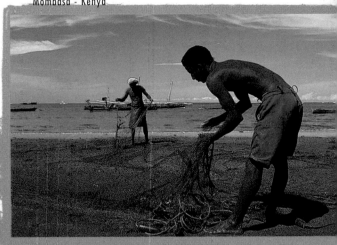

Technical Details

35mm Single Lens Reflex - 24mm lens, polarising and 81C warm-up filters, Fuji Velvia.

location
A farm near Tours - Loire, France

For this picture I chose a viewpoint which used the perspective effect to create bold diagonal lines which converged towards the farmhouse and emphasised its role as the main point of interest and also accentuated the impression of depth and distance in the image.

Choosing a Viewpoint

The choice of viewpoint is one of the most important decisions a photographer makes before taking a photograph. With subjects like portraits and still-lifes the subject itself can be arranged to adjust the composition but with other subjects such as buildings and landscapes this must be done by the choice of viewpoint and the way the image is framed. Many pictures lack impact because too much is included in the frame and the first question to ask yourself when considering a viewpoint is are you close enough?

Seeing

Watching this giant paella being made is like seeing a piece of theatre, the pan is well over a metre in diameter and it feeds more than 50 people. The initial reaction is to capture the action of the cook as he tips in bucketfuls of ingredients and stirs them with a huge paddle.

Thinking

But I also wanted to show the sizzling, colourful nature of the dish cooking, as well as the process of making it and decided to use a very close viewpoint to show the colour and texture of the food to its best advantage.

Acting

I used a wide-angle lens because this allowed me to shoot from very close to the pan and slightly above it while still being able to include all of the dish in the frame, together with the wood-fire flames flicking around its edges.

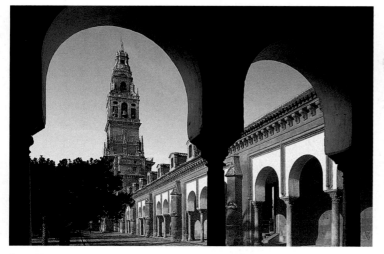

location
The cathedral courtyard, Cordoba - Andalucia, Spain

Rule of Thumb

When considering your choice of viewpoint it pays to look behind you as well as at your subject because it's often possible to find foreground details which can act as a frame to the composition, as in this picture taken through the arches of the cathedral courtyard. This can add an element of impact to the image, as well as increasing the impression of depth.

Technical Details
35mm Single Lens Reflex - 28mm perspective control lens,
polarising and 81C warm-up filters, Fuji Velvia.

Technical Details
35mm Rangefinder Camera - 28mm lens,
Kodak Ektachrome E100SW.

Composition

While choosing the viewpoint establishes the basic structure of the image, the perspective and the relationship between the objects within a scene, it's the way the image is framed which is responsible for the ultimate effect of a photograph. Inexperienced photographers often use the camera's viewfinder rather like a gunsight, as an aid to aiming the camera at the subject, ensuring it is accurately centred without being fully aware of the other objects included in the frame.

Seeing

The blaze of red from this poppy field was visible from some distance away and it took me only a short time to find the field. It was not only the colours of the poppies which appealed to me but also the row of trees and distant hillside.

Thinking

I walked along the edge of the field from which I could look across to the hill beyond, and which also placed the sun to one side producing a pleasing lighting quality. I eventually found a viewpoint which placed a good area of the poppies in an effective juxtaposition with the trees and an attractive section of the distant hillside.

Acting

It occurred to me that there were three distinct bands of colour, the pale blue sky, the strong green of the trees and hillside and the red poppies in the foreground. I decided to make this the crux of the composition choosing an upright format and using my zoom lens to adjust the framing so the three bands of colour were almost equal in area. I used a polarising filter to add strength to the colour of the sky and increase the colour saturation of the poppies.

Technical Details
6x4.5cm Single Lens Reflex - 55—110 zoom lens, polarising and 81C warm-up filters, Fuji Velvia.

Technical Details
35mm Single Lens Reflex - 50mm lens, Kodak Ektachrome 64.

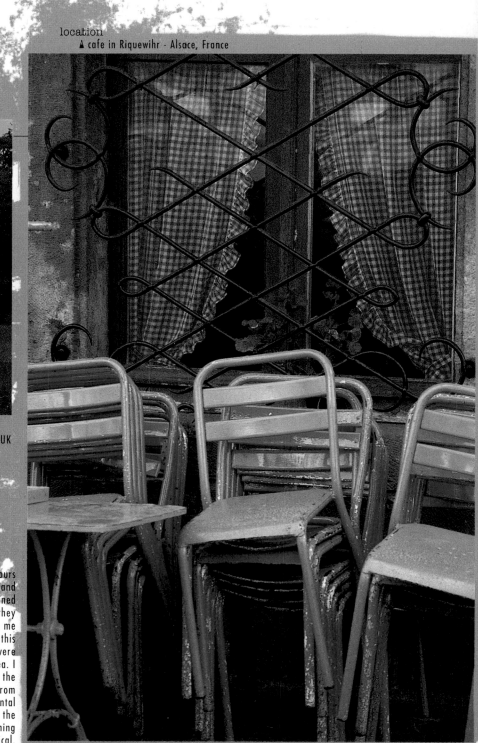

The contrasting colours of the blue chairs and the net curtain combined with the shapes they created suggested to me that I should frame this shot so that they were almost equal in area. I included a little of the wall and refrained from using a fully frontal viewpoint to prevent the composition becoming too symmetrical.

One of the most effective ways of producing striking, eye-catching images is by the careful use of colour. Inexperienced photographers often fall into the trap of believing that very colourful subjects make the best colour photographs. The opposite is closer to the truth, the more restricted the use of colour the more telling the result.

Technical Details
35mm Single Lens Reflex - 80–200mm zoom lens, 81C warm-up and neutral-graduated filters, Fuji Velvia.

location
Château Latour and its vineyard, Pauillac - Gironde, France

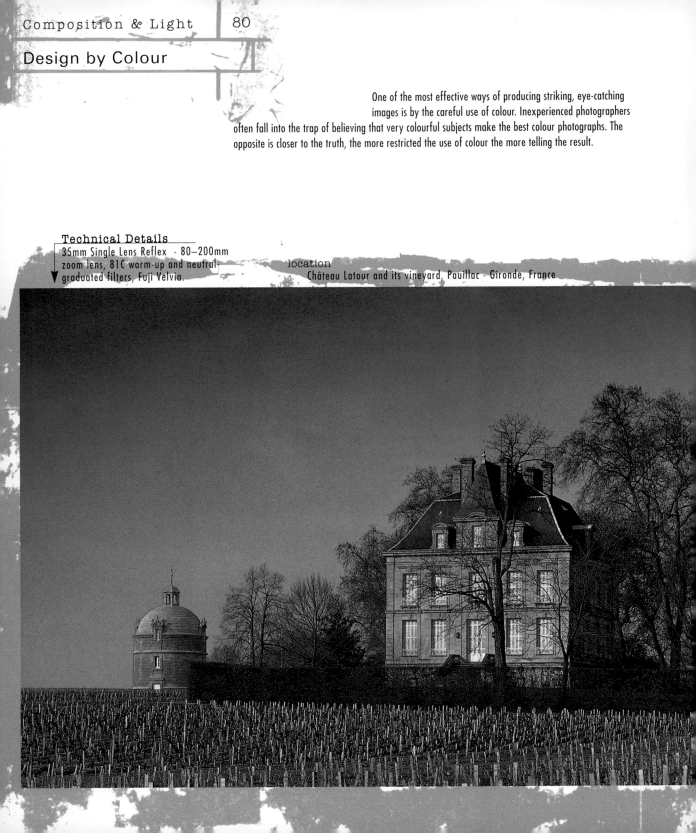

Seeing

This château and its distinctive tower is a well-known feature of the Medoc vineyards and I wanted to find a way of showing them both together. It was a winter morning, quite early, and the lighting from the more obvious viewpoint, showing the front of the château with the tower in the foreground, was unattractive.

Thinking

I decided to take a slow drive round the château, through its vineyards, heading in a direction which I thought would produce a more pleasing lighting effect. To my surprise I found that as I passed along this side of the château I could still see the tower and the sunlight was glancing off the stone in a very striking way.

Acting

As I was now a fair distance from the building I decided to use a long-focus lens to crop out some of the vineyard in the foreground and to give me a good-sized image of the château and tower. The lighting had already made the grey wintry sky seem quite dark but I used a neutral-graduated filter to increase this effect and an 81C warm-up filter to add some richness to the colour of the stone.

location
A street scene in Jaipur - Rajasthan, India

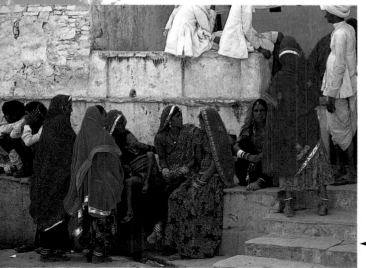

Rule of Thumb

As a general rule, brightly coloured subjects, such as this street scene, for instance, will photograph more pleasingly with a soft light, like that of a cloudy or hazy day, or in this case in open shade.

◄ Technical Details
35mm Single Lens Reflex - 35–70mm zoom lens, Fuji Provia.

The Evocative Detail

Although some travel destinations have instantly identifiable features, one of the potential disappointments of modern travel is that sometimes a new town or country simply does not seem different enough from more familiar places. Creating a sense of place in a photograph is something which is not always easily or automatically achieved and a keen, perceptive eye is often needed to recognise small details which will reveal the character and identity of a location.

Seeing

On calm mornings, groups of small fishing boats go out from numerous small beaches along this coast to fish close in-shore for anchovy fry. It was the combination of the quality of early morning light, the appealing shape of the boat and the reflections in the still water which tempted me to take this shot.

Thinking

The boats drop anchor and then drive a 100 metres or so away from it before lowering a net and then winching both boat and net slowly back to capture the fish. As it does so, the boat alters its angle both towards the light and to the beach. In some positions too much of the boat was in shadow and the two men were often awkwardly positioned.

location
An old mill house near Souillac - Dordogne, France

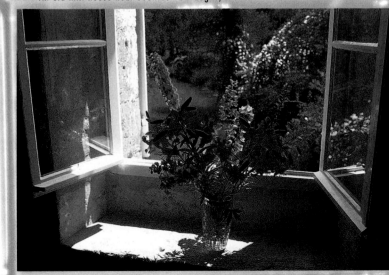

I had taken a number of exterior photographs of this charming old mill house and its setting beside a small stream was most attractive with a colourful wild garden beside it. However, it was this view from inside the house looking out on to the stream and garden which seemed to convey its atmosphere best.

Acting

Because the boat moved slowly, I was able to walk along the edge of the beach in pace with it until I found a spot where it was angled to the best effect for the light and waited until the two men moved into pleasing positions.

Technical Details
35mm Single Lens Reflex - 70–210mm zoom lens, 81B warm-up filter, 1/250 sec at f4.5, Fuji Velvia.

Technical Details
35mm Single Lens Reflex - 20–35mm zoom lens, polarising and 81B warm-up filters, Fuji Provia.

Using Daylight

It is often the quality of light which distinguishes a powerful and evocative image from a simple snapshot. Modern cameras, lenses and films make it possible to take photographs successfully in light so poor it would be difficult to read a book. The quantity of light falling on a subject is seldom a problem now but its quality remains an elusive factor.

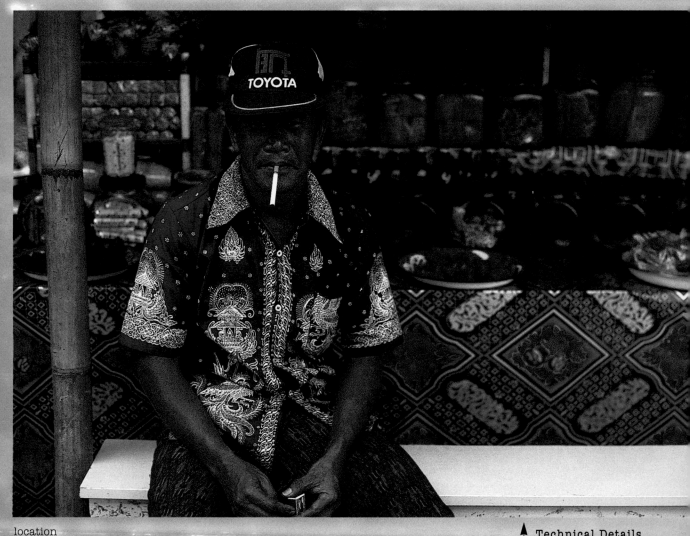

location
Street market - Bali

▲ Technical Details
35mm Single Lens Reflex - 35–70mm lens, Fuji Velvia.

Seeing

I saw this group of **sari-clad** ladies standing in a small street near a market. But the very bright **sunlight** tended to create a rather **muddled** and jarring quality.

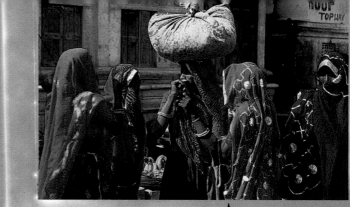

▲ **Technical Details**
35mm Single Lens Reflex – 75–300mm zoom lens, Fuji Provia.

Acting

My subjects looked settled in their conversation so I had **time** to take a slow walk around them and from this viewpoint I found that the sun was **lighting** them in a way which picked out the most dominant **colours** and the highlights created interesting shapes. From here, they were also placed in front of a **shaded** area of background which helped to **simplify** the image. I used my zoom lens to frame the shot in a way which isolated the most effective part of the scene and also cropped out the more distracting highlights and colours.

Thinking

I felt that if I could find a **viewpoint** from which the almost overhead **sunlight** created a better **balance** of light and shade it could produce a pleasing image.

Rule of Thumb

A potential problem with sunlight is that it can often create too much contrast, especially with subjects which are highly detailed or filled with bold colours, like this street scene for instance. The softer light of an overcast day can be far more sympathetic for situations like these. On a sunny day they have to be approached with care if muddled and jarring images are to be avoided. As a general rule it's best not to centre the subject in the frame. This image shows how a more effective composition can be created with careful framing.

Dawn, Dusk & Sunset

Staying up late and getting up early are two of the best ways of increasing your chances of taking pictures which stand out from the crowd. Not necessarily for the sake of a sunrise or sunset, dusk and dawn can create some quite subtle and beautiful effects even on a cloudy day. However, it's vital to know precisely where to go, it's no good getting up at 4.00 am and then driving round looking for something to photograph, this is a recipe for frustration and disappointment.

Technical Details ➤
35mm Single Lens Reflex - 35–70mm zoom lens, neutral-graduated filter, Fuji Velvia.

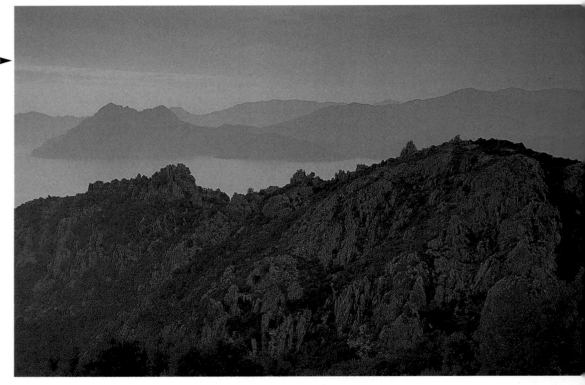

location
Les Calanches - Piana, Corsica

Rule of Thumb

As well as providing a striking quality of light, working at unsociable hours is also a useful way of photographing popular tourist spots which can be swarming with people during the normal hours. Few holidaymakers are prepared to miss breakfast and, up until around 9.00 am, you can often have the place to yourself. Quite apart from it being easier to take photographs at such times, there's something quite magical about places like this mosque before the crowds arrive.

location
Vineyards - near
Lac du Bourget -
avoie, France

Seeing

This rock formation is a very striking feature of the Corsican coastline and they are, naturally, a very rich red-rust colour. I first saw them on a dull, misty day and the dramatic appearance shown in this picture simply wasn't there.

Thinking

I felt that the most powerful effect would be created when the sun was itself quite red in the early morning or the late evening. But I also wanted to show the rocks with the sea in the background and this dictated the time of day – late evening.

Acting

Finding the best viewpoint was the most important part of shooting the picture and I spent an hour or so during the afternoon doing this. All that remained was to set up my camera and tripod and simply wait until the sun became low enough in the sky to create a really warm light. I used a neutral-graduated filter to help retain some tone and colour in the sky.

location
Jami Masjid Mosque - Old Delhi, India

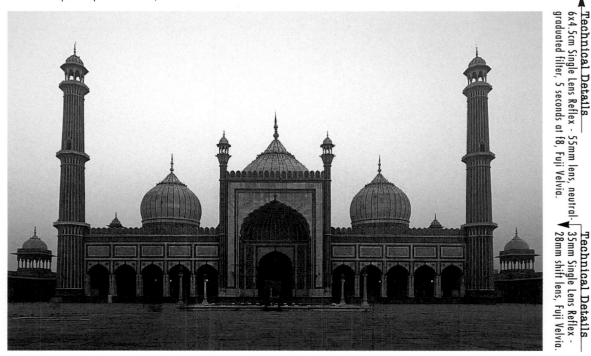

Technical Details
6x4.5cm Single Lens Reflex - 55mm lens, neutral-graduated filter, 5 seconds at f8, Fuji Velvia.

Technical Details
35mm Single Lens Reflex - 28mm shift lens, Fuji Velvia.

Dawn, Dusk & Sunset

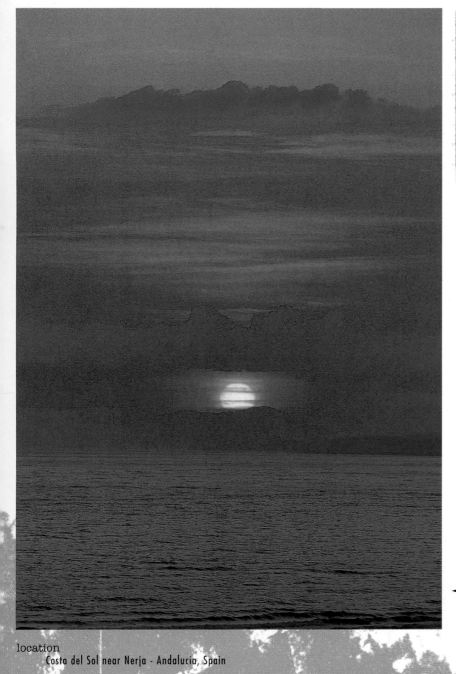

Rule of Thumb

When taking an exposure reading for a sunset a useful tip is to aim the camera just above or to one side of the brightest area of sky, where the sun itself is, and to make sure it is excluded from the reading. It is advisable to bracket your exposures when using transparency film giving a stop or so more and less than the indicated exposure in increments of one third or half a stop.

Technical Details ▶
6x4.5cm Single Lens Reflex - 50mm lens, neutral-graduated filter, Fuji Velvia.

◀ Technical Details
6x4.5cm Single Lens Reflex - 105–210 zoom lens, neutral-graduated filter, Fuji Velvia.

location
Costa del Sol near Nerja - Andalucia, Spain

The river Dordogne seen from the village of Domm - Dordogne, France

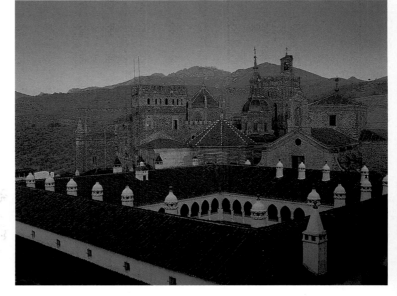

► Technical Details
35mm Single Lens Reflex
- 35–70mm zoom lens,
neutral-graduated filter,
Fuji Velvia.

This shot was taken looking towards the east just as the sun was beginning to rise. Because the landscape was much darker than the bright sky, I used a neutral-graduated filter to enable me to give enough exposure to record detail in the foreground without overexposing the sky.

Seeing

I found this viewpoint in the evening and it afforded a very good view of the monastery - the sun was behind the mountain and the lighting was quite interesting but the building itself was rather silhouetted.

Thinking

It occurred to me that the very first rays of the sun the following morning might create a very striking effect as they illuminated the monastery building.

Acting

I made sure that I was in the same spot the next morning well before the hour of sunrise and had my camera set ready on the tripod for that first glow of light. I used a graduated filter to make the sky a little darker.

location
The Monastery of Guadalupe - Extremadura, Spain

Bad Weather

The majority of travel photographs are shot in sunlight for the very obvious reason that such images tend to look more inviting. But shooting in bad weather can have very positive advantages as the resulting photographs will often have a more eye-catching and atmospheric quality.

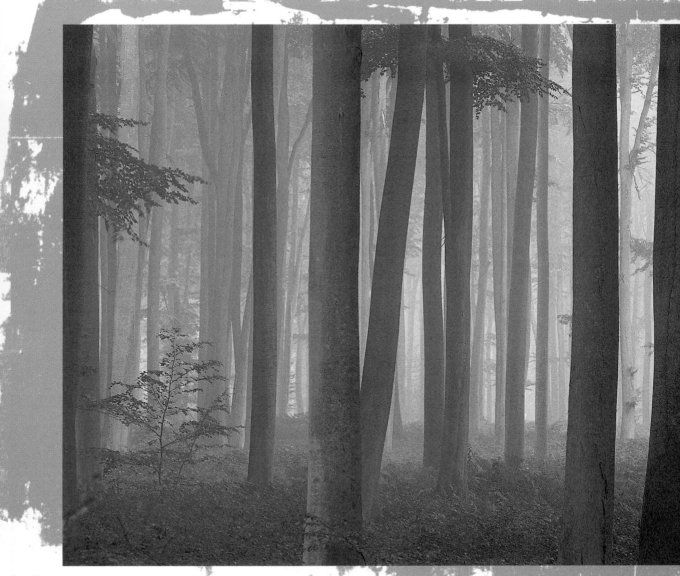

location
Forest at Lyons - Normandy, France

Technical Details
6x4.5cm Single Lens Reflex - 300mm
lens, 81B warm-up filter, 1 sec at
f22, Fuji Velvia.

location
Dovedale - Cumbria, UK

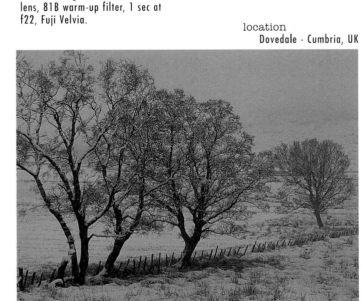

Technical Details
6x4.5cm Single Lens Reflex -
55-110 zoom lens, Fuji Velvia.

Seeing

On this morning, the countryside of
Normandy was blanketed in a thick fog
and it seemed as if there was little chance
of doing any photography. But driving
through this forest revealed a most
atmospheric scene with the
potential to produce some strong images.

Thinking

I felt that the most striking quality of the scene was the
strange juxtaposition of shapes created by
the tree trunks and this altered very significantly
as I changed the camera viewpoint and as the
mist swirled through the forest.

Acting

I walked slowly into the forest looking for the most
effective arrangement of shapes often
moving only a foot or so to obtain a very different
effect. This was, I felt, one of the most successful
images and I used a 300mm lens to isolate a
small section of the scene, which
accentuated the effect of the fog.

Dramatic Skies

The sky can be a very important element of many photographs. As a general rule, if it doesn't make a positive contribution to the image, when there is a blank white sky on an overcast day for instance, it's best, where possible, to exclude it altogether. But even when the sky is interesting there are a number of things you can do to maximise its effect.

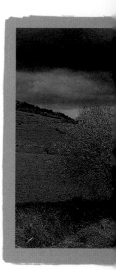

Seeing

It was the single, isolated tree set in this bleak rocky landscape which first caught my eye and it was not until I began to set up my camera that I noticed the approach of the small white cloud.

Thinking

I realised that if I could find the right viewpoint quickly, anticipating where the cloud would go, I could have a much stronger image than the one I had planned to shoot.

Acting

I fitted a polarising filter to obtain the maximum contrast between the cloud and blue sky and fitted a long-focus lens to exclude all but the tree and cloud, using an upright format. At the last moment I also decided to use a neutral-graduated filter to make the very top section of the sky and cloud a little darker.

location
Near Issoire - Auvergne, France

location
Near Clermont Ferrand - Auvergne, France

A graduated filter is invaluable for making the most of dark, brooding skies since they will often record lighter than appears visually if left unfiltered. This is because the exposure needed to produce a full range of tones and detail in the foreground will usually result in the sky being overexposed.

Technical Details
6x4.5cm Single Lens Reflex - 50mm lens, neutral-graduated and 81C warm-up filters, Fuji Velvia.

Technical Details
6x4.5cm Single Lens Reflex - 55–110 zoom lens, 81B warm-up filter, Fuji Velvia.

Technical Details
6x4.5cm Single Lens Reflex - 105–210 zoom lens, polarising, 81C warm-up and neutral graduated filters, Fuji Velvia.

location
 Near San Sebastian - Guipuzcoa, Spain

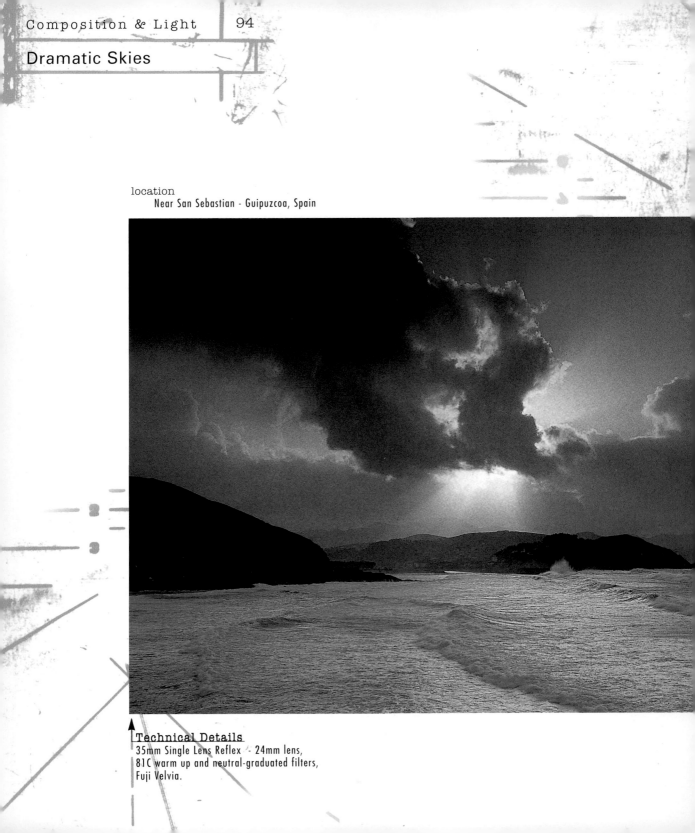

Technical Details
35mm Single Lens Reflex - 24mm lens,
81C warm up and neutral-graduated filters,
Fuji Velvia.

location
Win Green, near Shaftesbury - Wiltshire, UK

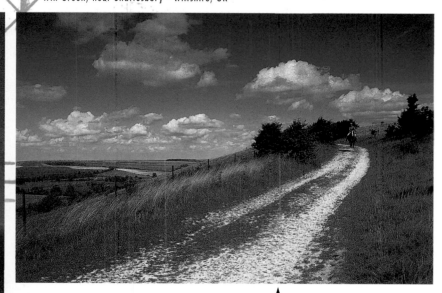

Technique

A graduated filter is most often used so that the line of graduation runs parallel to the horizon but with a square filter system they can be used at any angle, even upside down to make a foreground darker for instance. They can be especially useful when photographing a deep blue sky with a polariser when it has an uneven effect, a problem often encountered when using a wide angle lens. In such cases, like this summer landscape, the graduated filter can be used at an angle over one or other corner of the sky area to make it more even.

Technical Details
35mm Single Lens Reflex - 24mm lens, 81C warm-up, polarising and neutral graduated-filters, Fuji Velvia.

Available Light

Dark is a relative term, there are few outdoor situations where there is no light at all and it's quite possible to shoot pictures in moonlight with a long enough exposure if the subject is static and you use a tripod. When people are involved, or the subject is moving, the temptation is to use flash when the light is poor but this can easily destroy the atmosphere of a scene and making the most of the available light can be a better option.

Seeing

The atmosphere of a grape-pickers lunch is a lively one and this room in which they gathered was very large and poorly lit, but I felt that these qualities were essential to the picture.

Thinking

The room was simply too large to even consider the use of flash so I had to look for ways in which I could get a manageable exposure using the existing light - weak daylight filtering through small windows near the eaves.

Acting

This particular viewpoint allowed me to shoot towards one of the strongest light sources and the reflection it created on one of the tables. This gave the otherwise dark and shadowy scene a good area of highlight. I simply used the fastest film I had with me, set the widest aperture on my lens and waited for a moment when the people in the immediate foreground were fairly still before shooting at the necessary half-a-second shutter speed.

location
The refractory
of Château
Lascombes,
Margaux -
Gironde, France

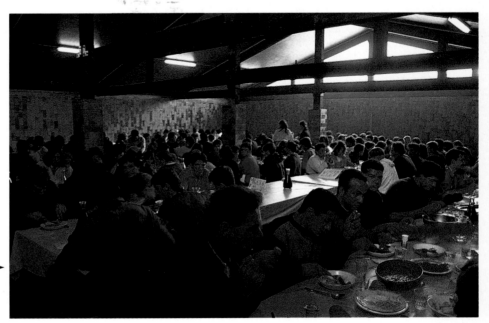

Technical Details
35mm Single Lens Reflex -
35–70mm zoom lens,
1/2 sec at f2.8,
Fuji Provia ISO 400.

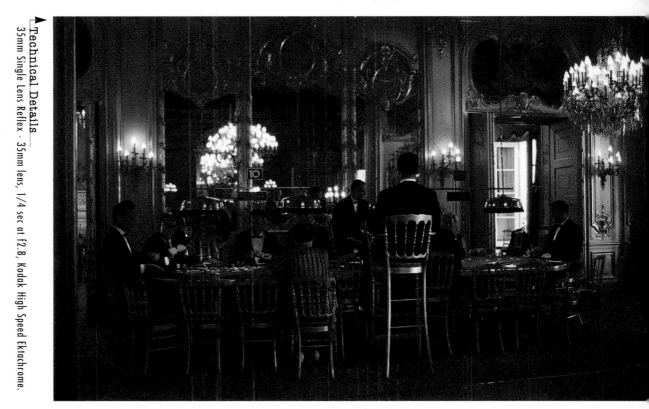

Technical Details
35mm Single Lens Reflex - 35mm lens, 1/4 sec at f2.8, Kodak High Speed Ektachrome.

location
The Casino - Baden Baden, Germany

location
A fromagerie
in Montmartre -
Paris, France

Technical Details
35mm Rangefinder Camera - 28mm lens,
1/60 sec at f2.8, Kodak E100 SW rated at ISO 200.

Rule of Thumb

The commonest problem when shooting
pictures in available light is that of
excessive contrast. You can do a great
deal to avoid this by choosing viewpoints
and framing your images in ways which
exclude both the brightest highlights and
the densest shadows.

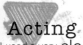

Seeing

I wanted to take a shot of the Christmas tree before it became completely **dark** but the **illuminations** were not switched on until all the light had gone from the sky.

Thinking

I thought that my best approach was to **fill** the frame with only the **illuminated** areas of the scene and to include the fountain in the foreground. This helped to make the sky less important and the fact that it recorded as **black** would then not detract too much from the picture.

Acting

I used a very **close** viewpoint and the long end of my medium range zoom to frame the image quite **tightly**. Although, by now, the scene was lit almost completely by **artificial** light I opted to use **daylight** film because I wanted the image to have a warm, golden quality.

Rule of Thumb

When shooting pictures of illuminated buildings or streets at night it is best to try and shoot before all the light goes out of the sky. This will help to reduce the contrast of the image, providing more shadow detail, and will allow the outlines of the buildings to be seen more clearly.

location
St Martins Lane - London, UK

Technical Details
35mm Single Lens Reflex - 35–70mm zoom lens, 1/4 sec at f2.8, Fuji Provia.

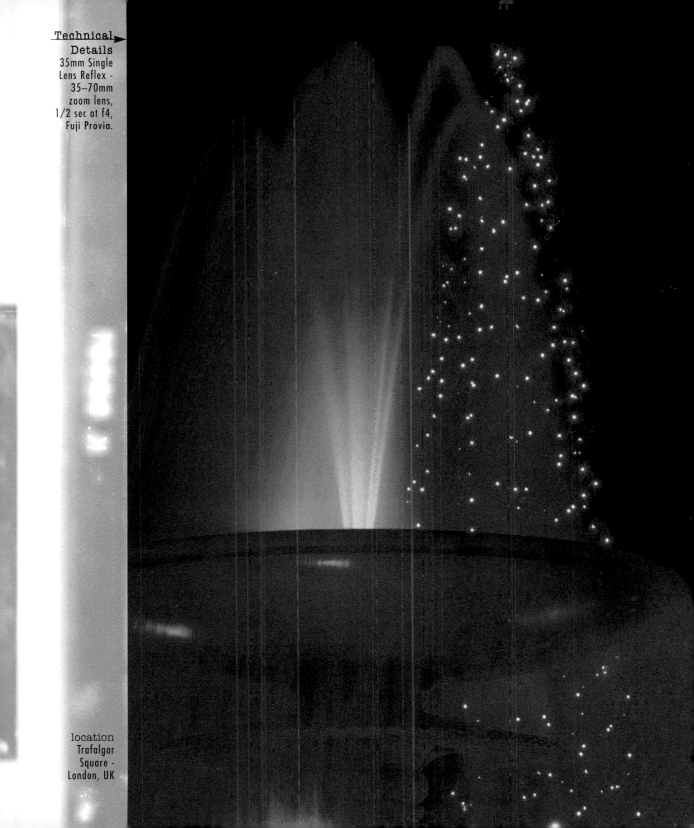

Technical ▶
Details
35mm Single
Lens Reflex -
35–70mm
zoom lens,
1/2 sec at f4,
Fuji Provia.

location
Trafalgar
Square -
London, UK

Flash has the drawback that it's not possible to actually
see the effect of the lighting until your film is processed. This means you need to think about the way it's
being aimed quite carefully in order to make an educated guess at it's effect.

Seeing

The situation had considerable potential, I thought, but it
depended upon seeing something of the extent of the
vast cellar and its countless bottles and also of the
action of the man who was turning them, an
important technique in champagne production.

Thinking

Flash alone would have resulted in the more distant area
of the cellar being a black abyss, whereas an
available-light shot would have resulted in the
man being largely in silhouette.

Technical Details
35mm Single Lens Reflex - 35–70mm zoom lens,
1/4 sec at f4 with fill-in flash, Fuji Provia.

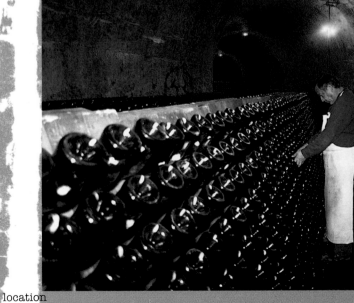

location
The Cellars of Moet et Chandon, Reims - Champagne Ardenne, France

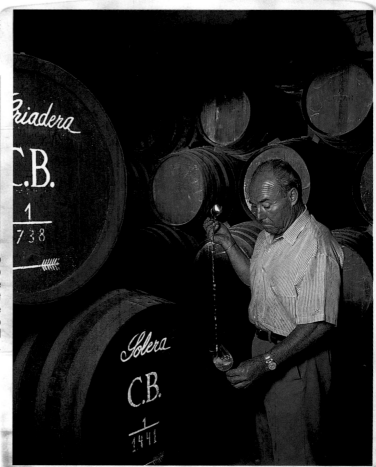

This cellar had virtually no
ambient light so I was obliged to
use flash exclusively. I set up one
flash behind the subject to light
the stream of wine and the
background barrels and another to
one side of the camera, diffused
with a softbox, to light the man.

Technical Details
6x4.5cm Single Lens Reflex -
55–110mm zoom lens,
two flash units at f5.6,
Fuji Provia.

Acting

I took an exposure
reading for the
ambient light
and set the
necessary shutter
speed and aperture. I
then adjusted the
power of the flash to
give a half stop less
than the strictly
correct exposure for
the flash
exposure, to avoid
the effect appearing
too artificial.

Rule of Thumb

The most common fault with flash-
on-camera shots is that of not
allowing for the quite dramatic
drop in light intensity as it travels
further from the gun. This can be
avoided by making sure the
distance from the camera to the
subject is always more than that
between the subject and the
background, preferably at least
double.

Equipment and Techniques

LANCASTER'S
PATENT
SEE SAW SHUTTER

4

Your choice of equipment will depend on
what you want out of your camera,
whether you wish to sell your work, which subjects you are likely to choose and
how much you can afford to spend. Some items are useful whatever subjects you
photograph while others have limited, specialist use.

Camera Types

The choice of camera, type and format for travel photography depends upon a number of factors. Versatility is perhaps one of the most important since a typical travel assignment might include such diverse subject matter as landscapes, architecture, food, interiors, still-lifes, action, portraits, close-ups, wildlife and so on.

Formats

Image size is the most basic consideration. The image area of a 35mm camera is approximately 24x36mm but with roll-film it can be from 45x65mm up to 90x60mm according to camera choice. The degree of enlargement needed to provide, say, an A4 reproduction is much less for a roll-film format than for 35mm and gives a potentially higher image quality.

For most photographers the choice is between 35mm and 120 roll-film cameras. APS offers a format slightly smaller than 35mm and for images larger than 90x60mm it is necessary to use a view camera of 5x4" or 10x8" format.

Pros & Cons

APS (Advanced Photo System) cameras have a more limited choice of film types and accessories and are designed primarily for the use of print film. 35mm SLR cameras are provided with the widest range of film types and accessories and provide the best compromise between image quality, size, weight and cost of equipment. Both accessories and film costs are significantly more expensive with roll-film cameras and the range of lenses and accessories more limited than with 35mm equipment. Facilities such as autofocus and motor drive are available on very few roll-film cameras while they are also generally heavier and bulkier than 35mm cameras. View cameras provide extensive perspective and depth of field control and are especially useful for architectural and still-life photography but are cumbersome and not user-friendly.

Camera Types

There are two basic choices between both roll-film and 35mm cameras, the Viewfinder Camera and the Single Lens Reflex, or SLR.

Pros & Cons

The SLR (Single Lens Reflex) allows you to view the actual image which is being recorded on the film while the viewfinder camera uses a separate optical system. The effect of focusing can be seen on the screen of an SLR but the whole image appears in focus when seen through a viewfinder camera. Generally, facilities like autofocus and exposure control are more accurate and convenient with SLR cameras and you can see the effect of filters and attachments with the latter. SLR cameras have a much wider range of accessories and lenses available to them and are more suited to subjects like wildlife needing very long-focus lenses and close ups. Viewfinder cameras tend to be lighter and quieter than SLRs.

Technical Details ▶
35mm Single Lens Reflex -
35mm lens, 81A warm-up filter,
Kodak Ektachrome 64.

location
Near Forcalquier - Alpes de Haute Provence, France

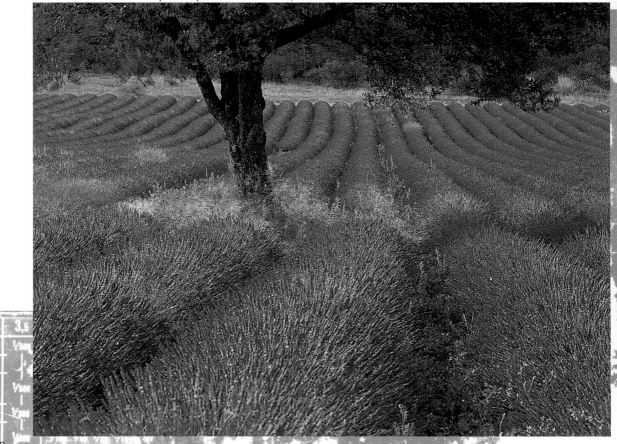

location
Via Dolorosa, Jerusalem - Israel

Technical Details
6x4.5cm Single Lens Reflex -
55–110mm zoom lens, 81C warm-up
and polarising filters, Fuji Velvia.

When there is time to set up and compose a static subject
like this it can be recorded with greater detail and quality
on a roll-film camera.

A 35mm
camera is
ideal for
hand-held
shots of
people in a
busy street,
as in this
photograph
of the
Easter
procession.

Specialist Cameras

While it's possible to produce panoramic format photographs with some ordinary 35mm and roll-film cameras, dedicated 60x120, 60x170 and 60x240 mm cameras are the professional's choice for travel photography, particularly landscapes. These are essentially viewfinder cameras taking 120 roll-film with a greatly elongated film chamber. Some have fixed wide-angle lenses while others have interchangeable lenses. An alternative to using a dedicated panoramic camera is to use a 60x120mm roll-film back with a 5x4" view camera.

In addition to conventional panoramic cameras there are also swing-lens cameras, such as the Widelux, giving a panoramic image over a wide angle of view. These can be bought in both 35mm and 120 film formats and have a moving lens mount which progressively exposes the film. This gives a more limited range of shutter speeds and also causes horizontal lines to curve if the camera is not held completely level.

When used with the right subject, the proportions of a panoramic image can create a striking image.

Underwater photography is sometimes part of a travel photographer's brief and this too needs special equipment. At the simplest level it is possible to buy weatherproof compact cameras which can be used at modest depths of a few metres. It's also possible to buy underwater camera housings to enable many normal cameras to be used at considerable depths but there are a number of specially-adapted cameras, such as the Nikonos, which allow greater flexibility and ease of use. Flash is essential for serious underwater photography as, at even quite modest depths, daylight becomes irreversibly blue in quality.

Technical Details
6 x 17cm Panoramic roll-film Camera -
90mm lens, 81C warm-up, centre and
polarising filters, Fuji Velvia.

location
Champagne vineyards seen from Mont Aimee, Cotes de Blancs - Marne, France

Choosing Lenses

A standard lens is one which creates a field of view of about 45 degrees and has a focal length equivalent to the diagonal measurement of the film format ie. 50mm, with a 35mm camera and 80mm with a 6x6cm camera.

Lenses with a shorter focal length create a wider field of view and those with a longer focal length produce a narrower field of view. Zoom lenses provide a wide range of focal lengths within a single optic, taking up less space and offering more convenience than having several fixed lenses.

location
Fatehpur Sikri -
Rajasthan, India

The ability to shift the field of view upwards, without having to tilt the camera, makes a perspective control lens invaluable for photographing buildings as it avoids the problem of converging verticals.

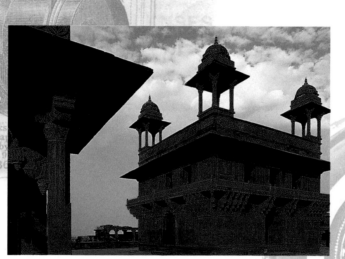

Pros & Cons

Many ordinary zooms have a maximum aperture of f5.6 or smaller. This can be quite restricting when fast shutter speeds are needed in low light levels and a fixed focal-length lens with a wider maximum aperture of f2.8 or f4 can sometimes be a better choice. Zoom lenses are available for most 35mm SLR cameras over a wide range of focal lengths but it's important to appreciate that the image quality will drop with lenses which are designed to cover more than about a three to one ratio, ie. 28–85mm or 70–210mm.

location
Bee Eater -
Masai Mara,
Kenya

An extreme long-focus lens with a wide maximum aperture is ideal for shots like this where you need to obtain a large image of a distant or very small subject and also use a fast shutter speed.

Technical Details

35mm Single Lens Reflex - 28mm perspective control lens, 81c warm-up and polarising filters, Fuji Velvia.

Special Lenses

For subjects like wildlife, a lens of more than 300mm will often be necessary and one between 400–600mm is often necessary to obtain close up images of wild animals and birds.

For those interested in architectural perspective, a control or shift lens can be a good investment. These allow the lens to be physically moved from its axis to allow the image to be moved higher or lower in the frame without the need to tilt the camera, thereby avoiding the converging verticals which this produces.

A macro lens is also very useful for those specialising in close-up images of subjects like flowers, making it possible to obtain life-sized images without the need for extension tubes or close-up attachments.

Extenders can allow you to increase the focal length of an existing lens, a x 1.4 extender will make a 200mm lens into 300mm and a x 2 extender to 400mm. There will be some loss of sharpness with all but the most expensive optics and a reduction in maximum aperture of one and two stops respectively.

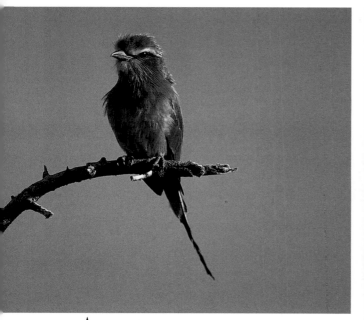

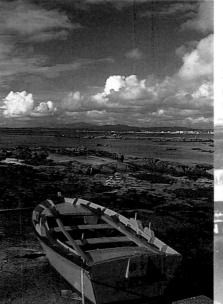

location
Near Cambados - Galicia, Spain

The angle of view of a 50mm lens, when used with the 35mm format, creates a similar effect to normal vision.

▲ Technical Details
35mm Single Lens Reflex - 600mm f4 lens,
81A warm-up filter, 1/500 sec at f4, Fuji Provia.

▲ Technical Details
35mm Single Lens Reflex - 50mm lens,
polarising and warm-up filters, Fuji Velvia.

Camera Accessories

There are a wide range of accessories which can be used to control the image and increase the camera's capability. Extension tubes, bellows units and dioptre lenses will all allow the lens to be focused at a closer distance than it's designed for and this can be useful, not only for obvious close-up subjects like, say, flowers, but also to allow tightly cropped portraits to be shot when the lens in use only focuses down to a couple of metres.

location
Kuda Bandos - Maldive Islands

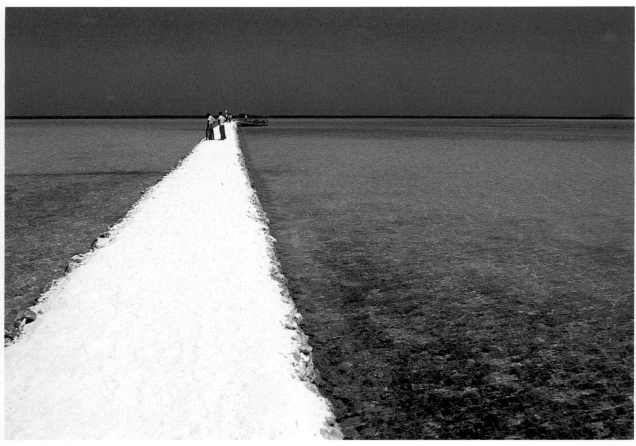

Technical Details

6x4.5cm Single Lens Reflex - 105–210mm zoom lens,
extension tube, 81A warm-up filter, Fuji Velvia.

Extension tubes can be used with any lens to enable them to focus at close
distances but are only available for SLR cameras with interchangeable lenses.

A range of filters is essential for both colour and black and white photography and a square filter system, such as Cokin or HiTech, is by far the most convenient and practical option. These allow the same filters to be used with all your lenses regardless of the size of the lens mounts as each can be fitted with an adapter upon which the filter holder itself can be easily slipped on and off.

The most basic filter kit should include a set of warm-up filters, a graduated and a polariser. For those shooting black and white a few contrast filters, such as yellow or red, are a useful addition. Polarisers are available in either linear or circular form. The former can interfere with some autofocussing and exposure systems – your camera's instruction book should tell you – but if in doubt use a circular polariser.

Perhaps one of the most important accessories is a tripod as it can greatly improve image sharpness and allow you to shoot pictures in low light levels where hand-held shutter speeds are not possible. It's best to buy the most substantial one you feel able to carry comfortably as a very lightweight tripod can be of very limited usefulness. A shake-free means of firing the camera, such as a cable release or a remote trigger, is advisable when using a tripod-mounted camera.

Although many cameras now have a built in flash these are usually of restricted power and a separate flash gun can be a very useful accessory. It will be much more powerful than one built in and it can be used off camera, fitted with a diffuser and used to bounce light from a ceiling. It's best to buy the most powerful which size and budget will allow.

A polarising filter can be used to make a blue sky a deeper and richer colour and give water a more translucent quality, as in this seascape.

Technical Details

35mm Single Lens Reflex - 20mm lens,
81C warm-up and polarising filters,
Fuji Velvia.

Technical Details

35mm Single Lens Reflex - 20mm lens, 4 secs at f5.6, Fuji Provia.

Shots like this church interior needing a long exposure would not be possible without a firm support like a tripod.

Apertures & Shutter Speeds

The aperture is the device which controls the brightness of the image falling upon the film and is indicated by f stop numbers; f2, f2.8, f4, f5.6, f8, f11, f16, f22, f32. Each step down, from f2.8 to f4 for example, reduces the amount of light reaching the film by 50 per cent and each step up, from f8 to f5.6 for instance, doubles the brightness of the image.

The shutter speed settings control the length of times for which the image is allowed to play on the film and, in conjunction with the aperture, control the exposure and quality of the image.

Technique

Choice of aperture also influences the depth of field, which is the distance in front and beyond the point at which the lens is focused. At wide apertures, like f2.8, the depth of field is quite limited making closer and more distant details appear distinctly out of focus.

The effect becomes more pronounced as the focal length of the lens increases and as the focusing distance decreases so with, say, a 200mm lens focused at two metres and an aperture of f2.8 the range of sharp focus will extend only a short distance in front and behind.

The depth of field increases when a smaller aperture is used and when using a short focal length, or wide-angle lens. In this way a 24mm lens focused at, say, 50 metres at an aperture of f22 would provide a wide range of sharp focus extending from quite close to the camera to infinity. A camera with a depth of field preview button will allow you to judge the depth of field in the viewfinder.

The choice of shutter speed determines the degree of sharpness with which a moving subject will be recorded. With a fast-moving subject, like an animal running for instance, a shutter speed of 1/000 sec or less will be needed to obtain a sharp image.

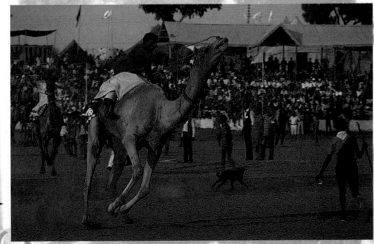

location
Pushkar camel fair - Rajasthan, India.
I used the fastest practicable shutter speed in order to obtain a sharp image of this speeding camel.

Technical Details
35mm Single Lens Reflex -
75-300mm zoom lens,
1/500 sec at f4, Fuji Provia.

Technical Details
35mm Single Lens Reflex - 80–200mm zoom lens, 1/250 sec at f2.8, Fuji Provia.

location
Samburu
tribesman -
Kenya

A long-focus
setting with
a wide
aperture
was used
for this
portrait in
order to
make use of
minimum
depth of
field and
throw the
background
out of
focus.

Technique

When a subject is travelling across the camera's view, panning the camera to keep pace with the movement will often make it possible to obtain a sharp image at slower speeds. This technique can be used to create the effect where the moving subject is sharp but the background has movement blur and can considerably heighten the effect of speed and movement.

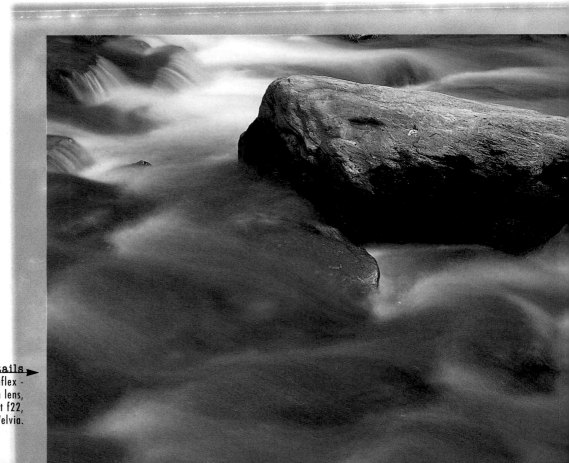

Technical Details ▶
35mm Single Lens Reflex -
80–200mm zoom lens,
polarising filter 2 secs at f22,
Fuji Velvia.

A sharp image of a moving subject is not always the best way of photographing it, however, and in some circumstances a very slow shutter speed can be used to create striking effects. A classic example is a waterfall.

A tripod must be used to ensure the static elements of the image are recorded sharply and then a slow shutter speed of, say, one second or more is selected to create a fluid smoke-like effect. The same technique can be applied very successfully to subjects like a busy street at night to record the light trails from moving vehicles. Images like this may need an exposure of several minutes.

location
The Pyrenees near Bielsa - Huesca, Spain
A small aperture was used for this mountainscape in order to obtain maximum depth of field.

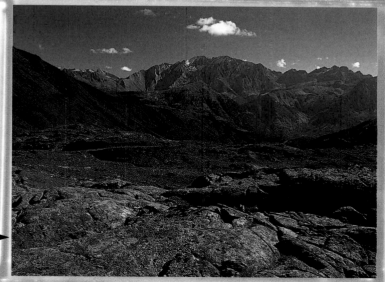

location
Trevelez, Alpujarras - Granada, Spain

I used a very slow shutter speed to create the smoke-like blur of this fast-running water.

Technical Details
6x4.5cm Single Lens Reflex - 50mm lens, 81C warm-up and polarising filters, 1/2 sec at f22, Fuji Velvia.

Film & Exposure

There is a huge variety of film types and speeds from which to choose and although, to a degree, it is dependent on personal taste there are some basic considerations to be made.

The choice between colour negative film and transparency film depends partly upon the intended use of the photographs. For book and magazine reproduction transparency film is universally preferred and transparencies are also demanded by most photo libraries. For personal use, colour negative film can be a better choice since it has greater exposure latitude and is capable of producing high quality prints at a lower cost.

With colour transparency film the colour quality of the light source is critical and a different type is needed for shots taken in artificial light whereas colour negative film can be used with all types of lighting and the colour adjusted at the printing stage.

Rule of Thumb

With all film types, its speed determines the basic image quality. A slow film of ISO 50 for instance, has finer grain and produces a significantly sharper image than a fast film of, say ISO 800. With colour film the accuracy and saturation of the colours will also be superior when using films with a lower ISO rating.

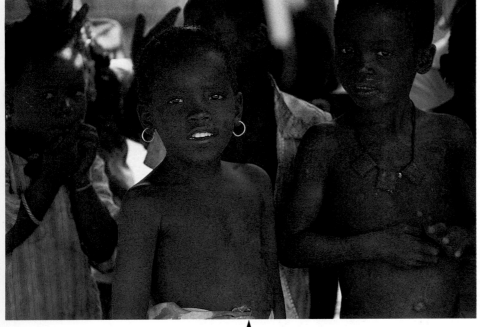

location
A village in the Gambia - West Africa

Technical Details
35mm Single Lens Reflex - 35–70mm zoom lens, Fuji Provia.

Technical Details
35mm Single Lens Reflex - 75–150mm zoom lens, 81B warm-up filter, Fuji Velvia.

Rule of Thumb

The most common situations in which the exposure taken from a normal average reading needs to be increased is when light sources are included in the frame, such as street scenes at night, when shooting into the light, when there are large areas of white or very light tones in the scene, such as a field of sunflowers in a landscape for example, and when there is a large area of bright sky in the frame.

Exposure

Modern cameras with automatic exposure systems have made some aspects of achieving good quality images much easier but no system is infallible and an understanding of how exposure meters work will help to ensure a higher success rate.

An exposure meter, whether it's a built in TTL meter or a separate hand meter works on the principle that the subject it is aimed at is a mid tone, known as an 18 per cent grey. In practice, of course, the subject is invariably a mixture of tones and colours but the assumption is still that, if mixed together, like so many pots of different-coloured paints, the resulting blend would still be the same 18 per cent grey tone.

With most subjects the reading taken from the whole of the subject will produce a satisfactory exposure. But if there are aspects of a subject which are abnormal, when it contains large areas of very light or dark tones, for example, the reading needs to be modified.

An exposure reading from a white wall, for instance, would, if uncorrected, record it as grey on film. In the same way a reading taken from a very dark subject, like a portrait of an African tribesman, for instance, would result in his skin being too light.

The exposure needs to be decreased when the subject is essentially dark in tone or when there are large areas of shadow close to the camera. With abnormal subjects it is often possible to take a close-up, or spot reading from an area which is of normal, average tone.

Technique

With negative films there is a latitude one stop or more each way and small variations in exposure errors will not be important but with transparency film even a slight variation will make a significant difference to the image quality and, where possible, it's best to bracket exposures giving a third or half a stop more and less than that indicated, even with normal subjects.

location
A village house near Blaye - Gironde, France

Travelling with a Camera

For the air traveller, and those using other forms of public transport, it's wise to be selective with the equipment you take as an unnecessarily heavy camera bag can soon become inhibiting as well as a tiresome burden.

An SLR camera with just two or more zoom lenses can provide a range of fields of view from very wide angle to long focus. With a 35mm SLR camera, a good basic choice of lenses would be a fixed 20mm or 24mm lens, a 28–85mm zoom and a 75–300mm zoom.

A spare camera body should be considered obligatory for serious travel photography. A small separate flash gun can be very useful both for use in very poor light and as a fill-in flash to reduce contrast and is a better option than those which are built into some cameras.

A set of filters is essential, especially when shooting colour transparency film. A useful kit would include a selection of warm-up filters 81A, 81C, 81B, a neutral-graduated filter and a polarising filter.

Technique

The polarising filter is one of the most useful additions to making blue skies a deeper colour. It can also give water a more translucent quality and reveal a much richer and wider range of hues in a blue sea. The polarising filter can also be used to increase the colour saturation of foliage quite dramatically, even on overcast days, and can help to give greater clarity when shooting distant views. It's also very useful for subduing excessively bright highlights when shooting into the light, like the sparkle on rippled water for example.

Graduated filters are the in-camera equivalent of shading and dodging in the darkroom. By sliding the filter up and down, or rotating it in its mount, you can make either the top, bottom or sides of the image darker, or a different colour.

Warm-up filters are designed to decrease the colour temperature and are graded in strength from 81 to 81EF, the latter being the strongest. They are essential when shooting outdoors on colour transparency film as the colour temperature of daylight can increase far beyond that for which daylight film is balanced and create a pronounced blue cast, especially on overcast or hazy days, at high altitudes, near the sea and beneath a deep blue sky.

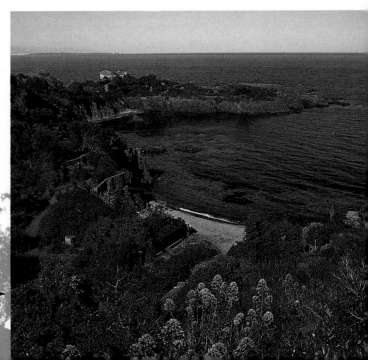

Technical Details
6x4.5cm Single Lens Reflex - 50mm lens, 81EF warm-up and polarising filters, Fuji Velvia.

Rule of Thumb

It's essential to carry spare batteries as they always tend to fail at the most inconvenient times and some types can be difficult to find in many destinations. Although most popular print films can be bought widely throughout the world black and white and transparency films can be much harder to find. It's best to be independent and carry all you need for a trip to ensure that it's fresh and you have your favoured brand.

Conversion filters are designed to allow **daylight film** to be used in **tungsten light** – 80A, and tungsten light film in daylight – 85C. To eliminate the colour cast when daylight film is used with **fluorescent** lighting the filter needed is the **magenta-tinted** FLD .

Some form of close-up device, such as **extension tubes** or a **macro** lens, is an extremely useful addition to a travelling outfit. A **tripod** should be considered obligatory as they can make an enormous difference to both the **sharpness** and **quality** of your pictures, as well as greatly increasing the opportunities for photography.

A **soft bag** is ideal for travel photography as it is light and affords easy access while on the move. It is not recommended, however, for placing in **luggage holds** and subjecting to the rigours of handling systems where a **rigid metal foam-filled** case is more advisable. Equipment can be transferred into a soft bag as needed on arrival.

Rule of Thumb

Avoid the temptation to take new and untried pieces of equipment and give your cameras and lenses a thorough check and clean before you leave, especially if some items have not been used for some time. It's also wise to carry out regular checks during the trip as well as basic cleaning.

location
The Esterel coastline near St Raphael - Var, France

I used a strong warm-up filter for this seascape to offset the potential blue cast caused by midday sunlight, a deep blue sky and the ultra-violet light which is particularly strong near the sea and at high altitudes.

Planning a Trip

The success of a photographic trip, even just a day out,
depends a great deal upon planning and direction as it's important to have clear objectives
and aims for the photographs you intend to take.

Technique

It's a good idea to write a list of the subjects you intend to photograph and, where possible, to mark the locations on a map with a highlight pen so that you have a rapid reference to the places you need to go.

Technique

In addition to bookshops and libraries, regional and national tourist offices are often ideal sources of local information and a letter or fax to the public relations department can provide you with most of the things you need to know. Studying local postcards is also a helpful short cut to finding good subjects. As well as the important sites and places of interest, it can be very useful to have a list of events such as fairs and festivals, as well as more everyday activities like markets.

location
A village house near
Blaye - Gironde, France

This detail of shuttered windows and flowers, which I felt seemed to typify the French rural scene, helped to identify the location as well as being an attractive image.

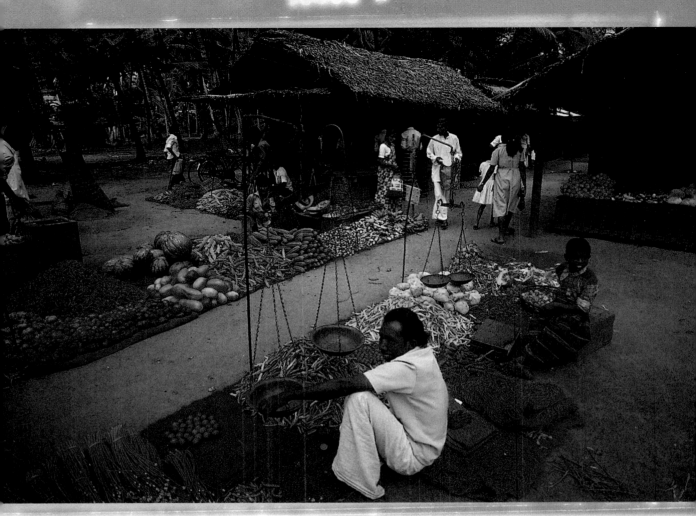

location
 A country market near Colombo - Sri Lanka
Local tourist information led me to this colourful village market.

Technical Details
 35mm Single Lens Reflex - 24mm lens,
 81B warm-up filter, Fuji Velvia.

Technical Details
 35mm Single Lens Reflex - 75–150mm zoom lens,
 81B warm-up filter, Fuji Velvia.

Presenting your Work

No matter how good your pictures are, if you cannot find them when needed and cannot identify them accurately, they are of limited use. And if they are poorly presented even the best photographs can fail to impress.

Captioning

Captions are very important for travel photographs, especially if you wish to have them published or submit them to photo libraries. Remember the five Ws rule for captioning – Where, What, Who, Why and When. A good, informative caption can help ensure that the image gets published.

With travel photographs, the geographical location is usually the prime category for images with an identifiable location. A simple system is to list the country first then the region, main town, and specific location before giving any further details.

Filing

With pictures captioned in this way you can file images according to the number you have of a given place, if you only have a few dozen of a region, such as Rajasthan for instance, they could all be filed under one heading but if you have hundreds they could be subdivided into principle towns. Photographs with a non-specific location can be filed under their subjects, such as flowers, animals, portraits etc.

Storage

Card mounts are by far the most suitable way of storing and presenting colour transparencies for submission to publishers and photo libraries. They can be printed with your name and address and with caption information. Added protection can be given by the use of individual clear plastic sleeves which slip over the mount.

The simplest way of storing mounted transparencies is in viewpacks – large plastic sleeves with individual pockets which can hold up to 24 35mm slides, or 15 of 120 transparencies. These can be fitted with bars for suspension in a filing-cabinet drawer and quickly and easily lifted out for viewing. For slide projection however, it is far safer to use plastic mounts, preferably with glass covers, to avoid the risk of popping and jamming inside the projector.

Presentation

When colour transparencies are to be used as part of a portfolio, a more stylish and polished presentation can be created by using large black cut-out mounts which hold up to 20 or more slides in individual black mounts, depending upon format. These can be slipped into a protective plastic sleeve with a frosted back for easy viewing.

Prints, black and white or colour, are most effectively presented either individually, or perhaps with two or three compatible images mounted on a page, in a portfolio. This can be in book form or as individual mounts in a case or box. For added protection it is possible to have prints laminated.

Editing

When selecting work for any form of professional **presentation** it is necessary to be very **critical** of your pictures. Transparencies need to be spot on for exposure and pin sharp, using a light box and a powerful **magnifier** to eliminate any which are sub standard.

It is also best to be quite **ruthless** about eliminating any rather similar or repetitive images. Even for personal use the **impact** of your photographs will be greatly increased if only the very **best** of each situation is included and a conscious effort is made to vary the nature of the pictures.

Technical Details
35mm Single Lens Reflex - 24mm lens, 81C warm-up, neutral-graduated and polarising filters, Fuji Velvia.

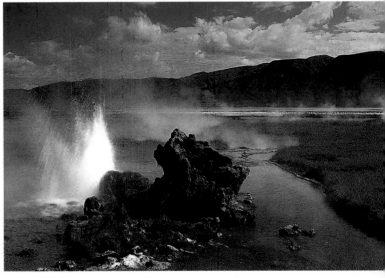

location
I have captioned this shot in the following way.
Lake Bogoria, Kenya - Africa
One of the numerous hot springs on the shore of this soda lake known for its large resident population of flamingos.

Selling your Work

There are a number of ways of finding a potential outlet for your work. The first is to exploit any other interests or expertise you might have. You may well buy, or read, magazines relating to other interests which have a travel context, such as golf, fishing, gardening, food and wine or walking for example. Good photographs of activities like these are in constant demand and there is a ready market for most subjects if the photographs are well executed.

Researching the Market

Spend some time in your local library, or at a friendly newsagents, and see just how the photographs are used in such publications and what type of image they seem to prefer. Make a note of some names, like the editor, features editor and picture editor.

There are some useful reference books available like the *Freelance Writers and Artists Handbook* and the *Freelance Photographers Market Handbook*, but these are, at best, only a general guide to potential users and it is vital to study each publication before you consider making a submission.

Think too about the pictures you have on your files in general, magazines represent only a tiny proportion of the publications which use photography. Travel brochures, for instance, are picture hungry and even fairly mundane shots like your holiday hotel or resort could be very welcome if it's well composed and has been shot under ideal conditions.

Illustrated Articles

While good individual photographs presented to the right publication stand a very good chance of being used there's no doubt that a complete package of words and photographs will stand a stronger chance. While the big glossy magazines will have well-known and regular writers, many smaller magazines have quite limited

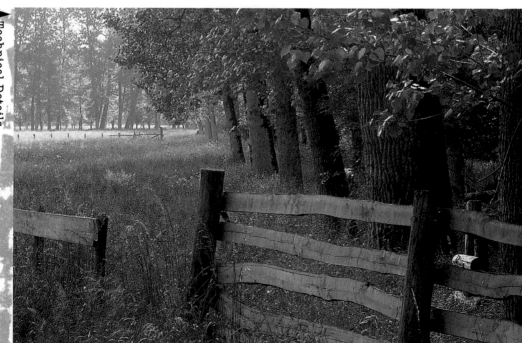

▲ Technical Details
6x4.5cm Single Lens Reflex - 55–110mm zoom lens,
81C warm-up and polarising filters, Fuji Velvia.

location
The Marais
Poitevin near
Coulon - Deux
Sevres, France

Generic images
like these are
often successful
with the large
international
photo libraries as
they are suitable
for many
purposes. This
shot has sold
countless times
for uses ranging
from magazine
articles on the
environment to
air-conditioning
brochures and
tranquiliser
advertisements.

resources and a clearly-written article of about a thousand **words** with a good selection of informatively-captioned **photographs**, illustrating the points made and the places described, will be a very tempting proposition.

Photo Libraries

A good photo library can reach infinitely more potential picture buyers than is possible for an individual and can also make sales to the **advertising** industry where the biggest reproduction **fees** are earned.

Making a Submission

As a general rule, you will be expected to submit **several hundred** transparencies initially, and will probably be obliged to allow those selected to be retained for a minimum period of three years. Your selection should be ruthlessly edited as only **top-quality** images will be considered and you should make sure that similar photographs are not sent, only the very best of each situation.

Although a good photo library can produce a substantial **income** in time from a good collection of photographs, it will take as much as a year before you can expect any returns and most libraries prefer photographers who make contributions on a fairly **regular** basis.

location
The River Oykel · Scotland

Technical Details
35mm Single Lens Reflex-
75–150mm zoom lens,
81C warm-up filter, Fuji Velvia.

A special knowledge or interest in a a topic like fishing, which is catered for by a large number of magazines and book publishers, can also produce images which have potential in a wide variety of other markets. This shot was used in a time-share brochure.

Aperture Priority

An auto-exposure setting in which the user selects the aperture and the camera's exposure system sets the appropriate shutter speed.

APO lens

A highly corrected lens which is designed to give optimum definition at wide apertures. It is most often available as better quality long-focus lenses for subjects likes sports and wildlife photography.

Auto Bracketing

A facility available on many cameras which allows three or more exposures to be taken automatically in quick succession giving both more and less than the calculated exposure. Usually adjustable in increments of one third, half or one stop settings and especially useful when shooting colour transparency film.

Bellows Unit

An adjustable device which allows the lens to be extended from the camera body to focus at very close distances.

Bounced Flash

The technique of reflecting the light from a flash gun from a white ceiling or wall in order to diffuse and soften the light.

Cable Release

A flexible device which attaches to the camera's shutter release mechanism and which allows the shutter to be fired without touching the camera.

Data Back

A camera attachment which allows information like the time, and date to be printed on the film alongside, or within the images.

Dedicated Flash

A flash gun which connects to the camera's metering system and controls the power of the flash to produce a correct exposure. Will also work when the flash is bounced or diffused.

Depth of Field

The distance in front and behind the point at which a lens is focused which will be rendered acceptably sharp. It increases when the aperture is made smaller and extends about two thirds behind the point of focus and one third in front. The depth of field becomes smaller when the lens is focused at close distances. A scale indicating depth of field for each aperture is marked on most lens mounts and it can also be judged visually on SLR cameras which have a depth of field preview button.

DX Coding

A system whereby a 35mm camera reads the film speed from a bar code printed on the cassette and sets it automatically.

Evaluative Metering

An exposure meter setting in which brightness levels are measured from various segments of the image and the results used to compute an average. It's designed to reduce the risk of under - or overexposing subjects with an abnormal tonal range.

Exposure Compensation

A setting which can be used to give less or more exposure when using the camera's auto-exposure system for subjects which have an abnormal tonal range. Usually adjustable in one third of a stop increments.

Extension Tubes

Tubes of varying lengths which can be fitted between the camera body and lens used to allow it to focus at close distances. Usually available in sets of three varying widths.

Fill In Flash

A camera setting, for use with dedicated flash guns, which controls the light output from a flash unit to be balanced with the subject's ambient lighting when this is too contrasty or there are deep shadows.

ISO Rating

The standard by which film speeds are measured. Most films fall within the range of ISO 25 to ISO 1600. A film with double the ISO rating needs one stop less exposure and a film with half the ISO rating needs one stop more exposure. The rating is subdivided into one third of a stop setting ie. 50; 64, 80,100.

Macro Lens

A lens which is designed to focus at close distances to give a life-size image of a subject.

Matrix metering

See 'Evaluative metering'.

Mirror Lock

A device which allows the mirror of an SLR to be flipped up before the exposure is made to reduce vibration and avoid loss of sharpness when shooting close-ups or using a long-focus lens.

Programmed Exposure

An auto-exposure setting in which the camera's metering system sets both aperture and shutter speed according to the subject matter and lighting conditions.

These settings usually offer choices like landscape, close up, portrait, action etc.

Reciprocity Failure

The effect when very long exposures are given. Some films become effectively slower when exposures of more than one second are given and doubling the length of the exposure does not have as much effect as opening up the aperture by one stop.

Shutter priority

A setting on auto-exposure cameras which allows the photographer to set the shutter speed and the camera's metering system selects the appropriate aperture.

Spot Metering

A means of measuring the exposure from a small and precise area of the image. This is often an option with SLR cameras. It is effective when calculating the exposure from high contrast subjects or those with an abnormal tonal range.